IN MEMORIAM

SO·THE·HEART·BE·RIGHT

Joanna Defrates

1945-2000

MAN THROUGH HIS ART

VOLUME 6

The Human Face

Educational Productions Limited

The general concept of the series has the approval of UNESCO, but the detailed selection of material for inclusion in each volume has been the responsibility of the authors, accepted by the World Confederation of Organizations of the Teaching Profession

FIRST EDITION 1968

Published by E. P. Publishing Company Limited for
EDUCATIONAL PRODUCTIONS LIMITED, 17 Denbigh Street, London SW1

© Editors: Anil de Silva and Otto von Simson

Printed in Italy
7158 0325 5

General preface

THROUGH the ages man has recorded the experience of his every-day life in his art. From the earliest rock carvings and paintings on cave walls down to modern times, man has recorded his reactions to his environment on canvas, in stone, in pottery and through statues.

The World Confederation of Organizations of the Teaching Profession is pleased to contribute to man's understanding of himself and his heritage by sponsoring *Man through his Art*. It is hoped that the volumes in this series, dealing with different aspects in the life of man, will enable teachers to instil in their pupils a mutual appreciation of Eastern and Western cultural values and a greater depth of international understanding.

The inspiration and creative efforts of the editors, Madame Anil de Silva and Professor Otto von Simson, have made this series possible.

William G. Carr, Secretary-General
World Confederation of Organizations of the Teaching Profession

Editors and contributors

EDITORS **Madame Anil de Silva**
Professor Otto von Simson

ASSOCIATE EDITORS **Sēnake Bandaranayake,**
Queen's College, Oxford
Professor Soichi Tominaga,
Director of the National Museum of Western Art, Tokyo, Japan

CONTRIBUTORS **Sēnake Bandaranayake,**
Queen's College, Oxford

Marcel Brion,
Académie Française, Paris

Professor François Chamoux,
Department of Greek and Roman Antiquities, The Sorbonne, Paris

Count Rüdt von Collenberg,
Art Historian, Paris

Fernando Gamboa,
Mexico, author of *Chefs d'Oeuvre de l'art mexicain*, etc.

Mrs. H. G. Frankfort,
author of *Arrest and Movement in Art*, etc.

Dr. F. Grossman,
Deputy-Director, City Art Gallery, Manchester
author of *Brueghel*, etc.

Charles Arsène-Henry,
author of *Statuettes-Portraits Japonaises*

Dr. Roger Hinks +
author of *A Catalogue of Greek and Roman Paintings and Mosaics in the British Museum, A Handbook of Greek and Roman Portrait Sculpture*, etc.

Dr. Justus Müller Hofstede,
The University of Bonn

André Malraux,
author of *Le Musée Imaginaire, Les Voix du Silence*, etc.

Madame Anil de Silva,
author of *The Life of Buddha* and *Chinese Landscape Painting from the Caves of Tun-Huang*

Professor Otto von Simson,
Die Freie Universität, Berlin
author of *The Gothic Cathedral*, etc.

Denys Sutton,
editor of *Apollo*, author of *American Painting*, etc.

William B. Trousdale,
Freer Gallery of Art, Washington

Dr. Christian Wolters,
Director of the Doerner-Institut, Munich

Hilde Zaloscer,
author of *Porträts aus dem Wüstensand – die Mumienbilder aus dem Fayum*, etc.

Contents

Acknowledgements

THE EDITORS cannot record their thanks individually to all those who have given their disinterested help and encouragement to this project from its inception.

Special thanks are due to the Asia Society, New York, who provided assistance for the preparative work of this project, and to the Unesco Secretariat, without whose constant guidance and active assistance this project could not have materialized.

A debt of appreciation is also acknowledged to the National Commissions for Unesco of Cambodia, the Federal Republic of Germany, France, Great Britain, India, Italy, New Zealand, the Sudan, Sweden, the UAR, and the USA. The illustrations are reproduced by the courtesy of the following museums, private collectors and photographers:

Introduction Fig. a, Directorate General of Antiquities, Baghdad; Fig. b, The Metropolitan Museum of Art, Carnarvon Collection (Gift of Edward S. Harkness, 1926); Fig. c, Louvre Museum, Paris: photo Musées Nationaux; Fig. d, Victoria and Albert Museum, London; Fig. e, Museo Barracco, Rome: photo Alinari, Rome; Fig. f, Louvre Museum, Paris: photo Archives Photographiques, Paris; Fig. g, photo Rapho, Paris; Fig. h, (C) Unesco/Cart 1962; Fig. i, Sono Budojo Museum: photo Frédéric, Agence Rapho, Paris; Fig. j, Museo Nazionale Florence: photo Alinari, Florence; Fig. k, National Gallery, London; Fig. l, National Gallery, London; Fig. m, British Museum, London; Fig. n, photo Hickey & Robertson, Houston, Texas. Plate 1, Cairo Museum: photo Hirmer Verlag, Munich. Fig. 1a, Neues Museum, Berlin: photo Bildarchiv Foto, Marburg; Fig. 1b: photo Hirmer Verlag, Munich; Fig. 1c: photo Giraudon, Paris; Fig. 1d, Collection and photo Staatliche Museen, Berlin; Fig. 1e. Courtesy of the Oriental Institute. University of Chicago; Fig. 1f. Roemer-Pelizäeus Museum, Hildesheim; Fig. 1g, Cairo Museum: photo Kurtlange, Oberstdorf. Plate 2, Art Institute of Chicago, Mr. & Mrs. Edward Sonnens chein Collection: photo Art Institute of Chicago. Fig. 2a, British Museum, London; Fig. 2b, Academia Sinica, Nan-Kang, Taiwan; Fig. 2c, Collection Hua Shu-ho, Taipei, Taiwan: photo by kind permission of Mr. Hua. Plate 3, Louvre Museum, Paris: photo Réunion des Musées Nationaux, Paris, Fig. 3a, Acropolis Museum, Athens: photo Scala, Florence; Fig. 3b, Louvre Museum, Paris: photo Giraudon, Paris; Fig. 3c, Olympia Museum, Greece: photo Chevojon, Paris; Fig. 3d, Olympia Museum, Greece: photo Alinari-Giraudon, Rome-Paris. Plate 4, Museum of Fine Arts, Boston: photo Prof. R. V. Schoder, Loyola University, Chicago. Fig. 4a, Museum of Fine Arts, Boston; Fig. 4b, Museo Nazionale, Naples: photo Anderson, Rome; Fig. 4c, Louvre Museum, Paris: photo Giraudon, Paris. Plate 5, Stadtische Gallery, Frankfurt: photo Kurt Haase. Fig. 5a, Louvre Museum, Paris: photo Dominique Darbois, Paris; Fig. 5b, National Gallery, London; Fig. 5c, Kunsthistorisches Museum, Vienna. Plate 6, Dumbarton Oaks, Washington, Robert Wood Bliss Collection: photo Nicklas Murray. Fig. 6a, National Museum, Mexico: photo Gisele Freund, Paris; Fig. 6b, Musée de l'Homme, Paris: photo J. Oster, Musée de l'Homme, Paris; Fig. 6c, Dumbarton Oaks Collection, Washington, D.C.: photo Nickolas Murray. Plate 7, photo Frédéric, Agence Rapho, Paris. Fig. 7a: photo Musée Guimet, Paris; Fig. 7b: photo Sēnake Bandaranayake; Fig. 7c, National Museum, New Delhi: photo Julian Roberts, London. Plate 8, Office du Livre, Fribourg. Fig. 8a, Musée de l'Homme, Paris: photo O. de Langle; Fig. 8b, National Museum, Phnom Penh: photo Frédéric, Agence Rapho, Paris; Fig. 8c: photo Werner Bischof-Magnum, Paris. Plate 9: photo Comité d'Amitié et de Relations Culturelles avec l'Etranger, Sofia. Plate 10: photo Comte, Paris. Fig. 10a: photo Casa Ed. Francescana Frati Minori Conventuali; Fig. 10b: photo Alinari, Florence. Plate 11. Musée Hist. Des Textiles, Lyon: photo Studios Associes, Lyon. Plate 11A. Musée Guimet. Paris. Figs. 11a, and 11b. Freer Gallery of Art, Washington, D.C. Plate 12, British Museum, London. Fig. 12a, Koninklijk Instituut von der Tropen, Amsterdam; Fig. 12b, Collection of the Oni of Ife: photo British Museum, London; Figs. 12c, 12d and 12e, British Museum, London. Plate 13: photo Grassi, Sienna. Figs. 13a and 13b, photo Alinari, Florence; Fig. 13c, photo Marodni Galerie, Prague. Plate 14, Museo Nazionale, Naples: photo Scala, Florence. Fig. 14a, Museo Nazionale, Rome: photo Anderson-Giraudon, Rome-Paris; Fig. 14b, Kupferstichkabinett, Staatliche Museen, West Berlin; Fig. 14c: photo Giraudon, Paris; Fig. 14d, Galleria Borghese, Rome: photo Anderson-Giraudon, Rome-Paris. Fig. 14e, Museo Nazionale, Florence: photo Alinari, Florence. Plate 15, Staatliche Kunsthalle, Karlsruhe. Figs. 15a and 15b. Prado Museum, Madrid; Fig. 15c, Musée Royaux des Beaux-Arts, Brussels. Plate 16, National Gallery, London: photo John R. Freeman, London. Fig. 16a, Staatliches Museum, Dresden: photo Giraudon, Paris; Fig. 16b, National Gallery, London; Fig. 16c, Kupferstichkabinett, Staatliche Museen, West Berlin: photo Walter Steinkopf, Berlin; Fig. 16d, Kunsthistorisches Museum, Vienna; Fig. 16e, Louvre Museum, Paris: photo Giraudon, Paris; Fig. 16f, Iveagh Bequest, Kenwood, London: photo Greater London Council, Dept. of Architecture and Civic Design; Fig. 16g, Walraf-Richartz Museum, Cologne: photo Giraudon, Paris. Plate 17, Prado Museum, Madrid: photo Scala, Florence. Fig. 17a, Prado Museum, Madrid: photo Ediciones Artisticas Offo Los Mesejo 21, Madrid 7; Fig. 17b. Prado Museum. Madrid: photo Anderson-Giraudon. Rome-Paris; Fig. 17c, National Gallery, London; Fig. 17d, The Metropolitan Museum of Art, The H. O. Havemeyer Collection. Plate 18A, The Metropolitan Museum of Art, Gift of Bayard Verplanck, 1949. Fig. 18a. The Metropolitan Museum of Art, Rogers Fund, 1906; Fig. 18b, The Metropolitan Museum of Art, Bequest of Charles Allen Munn, 1924; Fig. 18c. The Metropolitan Museum of Arts, Bequest of Richard de Wolfe Brixey, 1943; Fig. 18d, The Metropolitan Museum of Art, Bequest of Mrs. Rosalie M. Gilbert, 1937. Plate 18, Staatliche Museen, West Berlin. Fig. 18e, National Gallery, London. Plate 19, National Gallery of Art, Washington, Chester Dale Loan: photo Scala, Florence. Plate 20A, Bibliothèque Nationale, Paris: photo Roger Viollet, Paris. Plate 20, Bayerische Staatsgemäldesammlungen, Munich: photo J. Blauel, Munich. Fig. 20a: photo Marc Vaux, Paris; Fig. 20b, Nasjonalgalleriet, Oslo: photo O. Vaering, Oslo; Fig. 20c, Munchmuseet, Oslo: photo O. Vaering, Oslo; Fig. 20d, Nationalgalerie, West Berlin: photo John R. Freeman, London.

Introduction

BOTH FOR the artist and for us who look at his work the human face is unlike any other theme of art. When a painter depicts a landscape or an animal, or even a group of people engaged in some common activity, he remains relatively aloof, a detached observer of these 'objects' of his artistic contemplation. Such detachment is not possible when the artist is confronted with the human face; then he finds himself in the presence of an existence like his own, of a glance directed at him in such a way that the observer himself is transformed into an 'object' and it is this encounter, this rapport, between two human beings that is, and has been through the ages, the concern of painter and sculptor whenever he sought to evoke a human face.

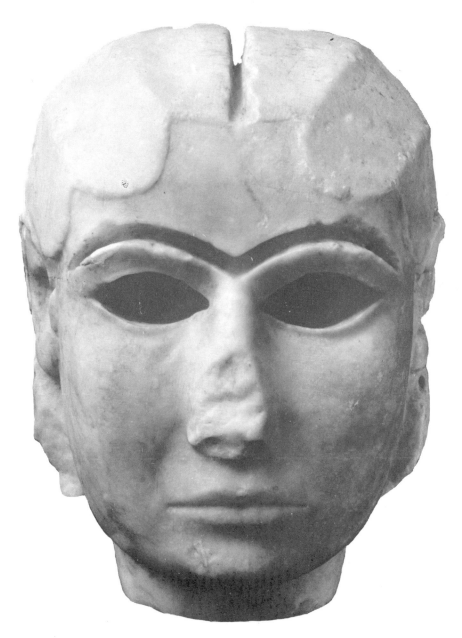

Fig. a. *Female head. Warka, Mesopotamia (Iraq). 4th millenium* BC.

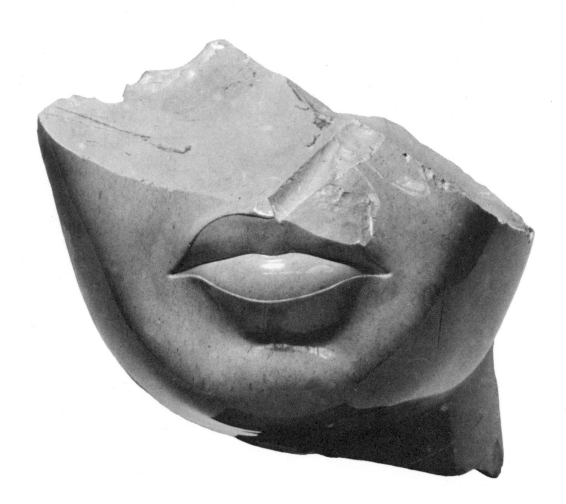

If the artist is successful he will convey this very experience to us. It does not matter whether his work represents the portrait of an individual, the image of a god or the incarnation of some virtue or vice; the onlooker will himself be drawn into a person-to-person relationship and this experience will play an important part in his appraisal of the work of art.

Representations of the human face appear with the earliest civilizations; they seem to be absent from prehistoric and so-called primitive art, both of which, as was pointed out in the Introduction to our volume on *Man and Animal*, are mainly concerned with man, not as distinct from, but as partaking of the life stream that permeates all existence. Consider the alabaster head from Northern Mesopotamia created nearly five thousand years ago (Fig. a). It is a highly formalized representation, infinitely remote from our life today. The artist has barely indicated age or sex; it is all the more remarkable that as we look at this head we are captivated by the feminine life it bespeaks, by the seriousness of mood, the youthful freshness of mouth and cheek; even the cavities of the eyes outline the wonderful immediacy and presence of a glance directed at us. In this work we also 'perceive and apprehend an essence that does not abide in other men', to quote Mr. Trousdale's felicitous definition of what is essential to the human face as a theme of art. In portraiture, this, of course, is the artist's abiding concern. Portraiture appears for the first time in Egypt; the head of Sesostris (Fig. 1c) does not immortalize the conventional image of a monarch, but the unique features of a disillusioned, aging man, in the twilight between power and death. Greek and Indian art, on the

Fig. b. *Fragment of a head of Queen Teye, Egypt, XVIIIth Dynasty. 1570–1314* BC.

Fig. c. *Goudea, Priest King of Lagash, Sumer (Iraq). ca. 2400* BC.

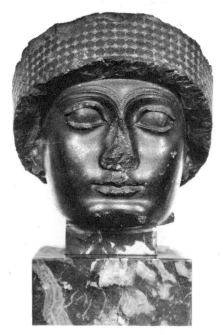

10

Fig. d. *The Prophet Haggai. Giovanni Pisano, Italy. 1285–1294* AD.

Fig. e. *Homer, Greece. 5th century* BC.

Fig. f. *Sesostris III (detail), Egypt, XIIth Dynasty. 1991–1785* BC.

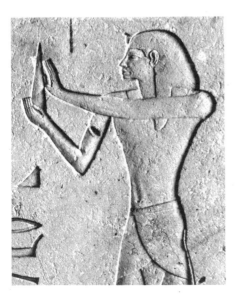

other hand, have become interested in portraiture only at a relatively late stage of their development. The splendid head of Homer, reproduced here (Fig. e), is not a portrait of the poet, but rather an image of an overpowering inner vision (of which Homer's legendary blindness had already in antiquity become a kind of symbol). We would say that in this sculpture something universal rather than individual, the ideal rather than the accidental features of a portrait are rendered palpable. Yet it is the mystery of the work that this experience of poetry, this reflection of the Homeric Epics in the soul of Greece, has come to life here as 'an essence which does not abide in other men', readable in the features of an aging man.

11

To some extent this dwelling together of the individual with the universally human appears in every representation of the human face by a great artist. It may take very different forms. Rubens, in his portrait of the Marchesa Veronica Spinola (Plate 15), blends the individual destiny of a young woman with the splendour and grace of her worldly estate. But, when Goya paints the King of Spain (Plate 17) we perceive an almost cruel discrepancy between the majestic trappings of royalty and the pathetic inadequacy and insecurity of the human being that peers out behind them, a discrepancy that is perhaps closer to tragedy than to farce. But with Rembrandt, the greatest portraitist of all time, the external marks or masks of man's estate seem to have become absorbed into his humanity. Rembrandt may put a fancy hat on the head of his model, or make him or her pose as an ancient philosopher, or as a woman from the Old Testament or from Greek Mythology, but the sheen of metal or jewellery, the textures of fur, satin or plumes are at once transfigured into the ineffable life of the soul.

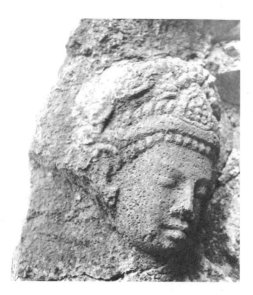

Fig. g. *Detail from a relief figure (probably a Bodhisattva), Ajanta, India. ca. 5th–6th century* AD.

Fig. h. *Faces (detail from Ramayana reliefs), Shiva Temple, Prambanam, Java, Indonesia. 9th–10th century* AD.

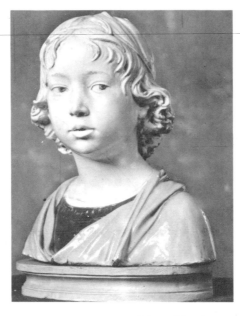

Fig. i. *Head of a devata (minor deity). Jog-Djakarta, Java, Indonesia. 8th–10th century AD.*

Fig. j. *A Boy. Andrea della Robbia (1435–1525 AD).*

Figs. k and l. *Members of a Confraternity, ascribed to Bergognone, Italy. (active 1481–1523 AD).*

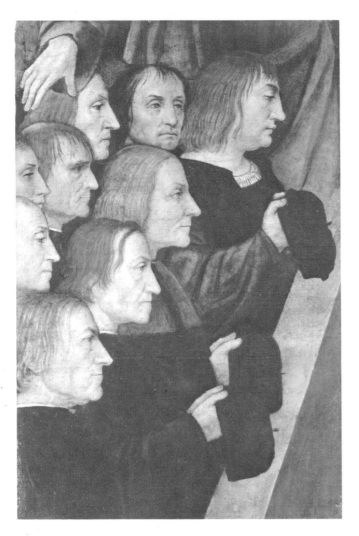

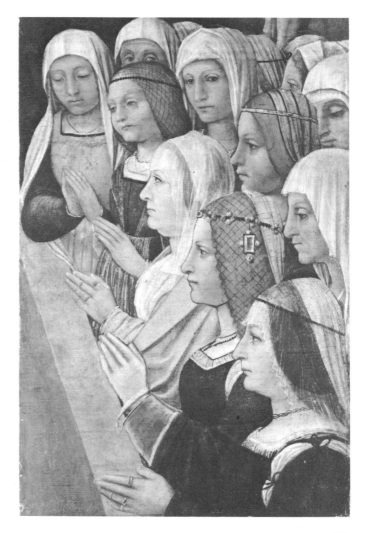

Rembrandt is, of course, the unsurpassed master of the *self-portrait* (Plate 16), a theme that is almost entirely limited – and very significantly so – to European art. This reflection in a mirror, this anxious, solitary probing into the self, as if it were a stranger, seems to have its ultimate roots in Christian experience. The Christian feels the eyes of God for ever fastened upon him; he also feels the passing of time like the flow of water, in the midst of which man's soul remains steadfast. We sense something of this dual experience in Taddeo di Bartolo's self-portrait (Plate 13), the earliest of its kind. Yet, this experience is not limited to the self-portrait; the two fragments of a painting by Bergognone depicting the members of a religious confraternity (Figs. k, l) join the different ages and personalities of these men and women into a common awareness of man's estate.

'When they made man,' we read in the *Upanishads*, the ancient Indian mystical texts, 'into how many parts did they make him?' In ever varying renderings of the human face, in portraits of men, women and children, warriors, poets and saints, art the world over has conveyed the image of mankind. The human face appears in almost every other album of this series, and the reader is referred to them for a more comprehensive view of this great theme. In these other volumes, the human face is connected with or subsumed under more general ideas, such as the idea of God, or of music, or of war and peace. We have hesitated whether to include in this album Segonzac's drawing of *Marcel Proust on his Deathbed* (Plate 20A), or whether its proper place would be in the volume devoted to death. We have decided to reproduce the drawing here because the features of the great writer appear, forbidding, withdrawn, silent, in that serenity by which death places a seal upon life.

Otto von Simson

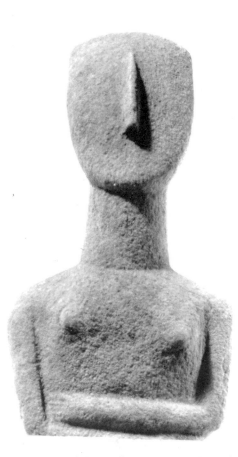

Fig. m. *Cicladic Doll, Greece (detail) 2nd millenium* BC.

Fig. n. *Mlle. Pogany by Constantin Brancusi, 1908.*

Khefren 1

Stone sculpture, Egypt, IV Dynasty, *c.* 2650 BC

To BEGIN a survey of the human face in art with examples of Egyptian sculpture appears an obvious choice. No other ancient civilization has produced so rich a harvest of plastic human figures, none a comparable variety in the treatment of the face alone. This may range from an astoundingly life-like portrayal to a formal stylization that is entirely removed from all-too-human associations, while, holding the balance between these extremes, an idealized version of the former may transcend the ephemeral character of mere individuality.

Fig. 1a. *King Chertihotep, Egypt. ca. 1900* BC.

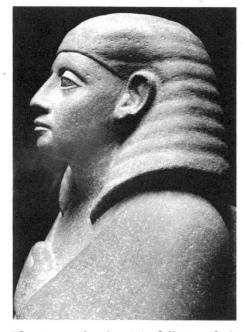

Fig. 1b. *Zoser, Egypt. ca. 2700* BC.

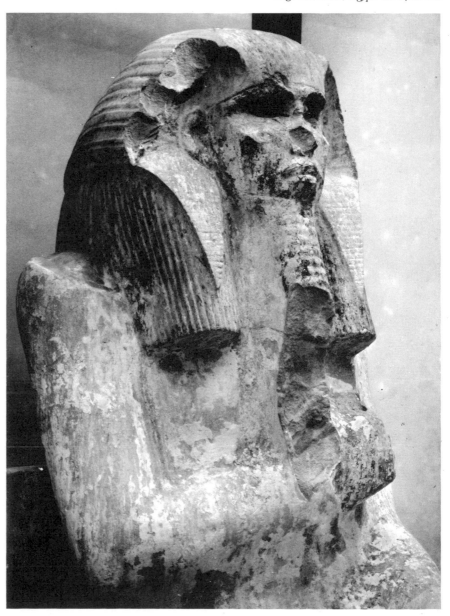

The term theology is fully justified, since kingship in Egypt was, notwithstanding its political implications, a religious concept. The different aspects of the pharaoh's divinity have been fully explored by Henry Frankfort in his *Kingship and the Gods.* He has rightly emphasized its unique character among various forms of kingship in the ancient Near East.

Generalizations on Egyptian art are admittedly hazardous; the discontinuity of Mesopotamian art, due to historic and ethnic upheavals, make them impossible. It seemed, therefore, advisable only to refer to early Sumerian art and to leave out of account, e.g., two isolated instances of highly individual royal portraits (only the heads have been preserved) attributed to an Akkadian

We intend to concentrate on the element of individual portrayal in Egyptian art mainly because it is rarely absent in the greatest works, but also because it poses a problem: why this persistent emphasis on personal identity? A rather glib answer is at hand, for the setting of Egyptian sculpture is predominantly funereal and its function explicit, namely to conjure up a living individual in a lasting form, to deny the finality of death. This has suggested to some scholars that, for all its grandeur and superb skill, Egyptian art was no more than a miraculous outgrowth of magic practices, the perennial attempt to cheat death by counterfeit life. Such a conclusion, however, bypasses the very real problem of the correlation between religion and art in Egypt.

It should be remembered that religious speculation in Egypt, in contrast with Mesopotamia, was focused not on the transcendent power of the gods and its dramatic impact on human destiny, but primarily on the manifestation of the divine in the permanent, the inexorable order of the cosmos, the movement of the celestial bodies, the rhythm of light and dark, growth and decay. Transcendent order, however, was not immanent in nature alone; it permeated the realm of human existence in the hierarchic structure of the state, which culminated in the divine king. It is significant that the earliest human images which are clearly identifiable do not represent deities (in fact, cult statues are rare in Egypt and appear comparatively late) nor votive figures of worshippers, but the pharaoh on whom order, justice and well-being in the state depended. In him, according to the theology of kingship (see note), the realm of the human and the divine interpenetrated. He was not, as elsewhere, the supreme servant of the gods; he embodied the divine, and since eternal life was of the essence of divinity, he must therefore be immortal. Hence the necessity of reasserting his immortality after his actual demise, in ritual, in poetic hyperbole, in the challenge of an indestructible monument and – what concerns us here most – in lasting images which were to preserve his identity and yet proclaim his having transcended time-bound existence. This paradox of the king's life-everlasting has been expressed superbly in this first truly great royal figure, the statue of King Zoser of the Third Dynasty (Fig. 1b). The statue, which was entirely walled up in a 'serdab' except for slits at eye level, represents the king as being dead, yet alive and watchful. Formally the solution is so impressive, its logic so simple, that it has been able to survive for millennia. It is the combination of a highly individual head with a body – in this case rather emaciated – whose rigid geometric structure (though it shows awareness of organic form under the clinging garment) appears to deny the essence of the organic, namely potential movement. The body's frozen immobility is more final than repose, but the face is intensely alive and forceful. It hints at tyranny as the reverse side of transcendent power.

The paradox implicit in the concept of a dead yet living king has not always been expressed in such a harsh contrast. The serenity of Khefren's face under the protection of the divine falcon – a serenity that is neither devout nor ecstatic, but supremely self-confident – blends harmoniously with the posture of the firmly modelled body.

In due course the emphasis in the portrayal of royal heads might shift in the direction of pronounced individuality, such as occurred in the Middle Kingdom, when the sad, brooding faces of some rulers, such as that of Sesostris III (Fig. 1c), suggest the loneliness, the burden of pharaoh's superhuman function; or it might tend towards greater stylization as in the New Kingdom. But the canonic formula for representing an individual *sub specie æternitatis* was adhered to throughout, with one exception, when during the brief Amarna revolution the king became the interpreter rather than the embodiment of divine power. The wonderfully subtle plaster mask of the prophet King

Fig. 1c. *Head of Sesostris III (fragment) Egypt, XIIth Dynasty. 1878–1843* BC.

ruler and to Hammurabi respectively. Their convincing imperiousness is entirely secular in feeling and in striking contrast with the humble devotion of the well-known statues of the Sumerian King Gudea.

Generally speaking, gestures in Egyptian statuary are merely explicative, such as that of the wife's arm round her husband in family groups. This also applies to what one might call the doll's house furniture of many tombs, namely the servant figures of the Old and Middle Kingdoms, busy at their tasks. These appear to point to a childish concept of the Hereafter as a ghostly replica of life on earth. Many texts, however, belie such a primitive outlook, even if it was never quite overcome. Then, as now, the temptation to project temporal values beyond the grave was ineradicable.

H. G. F.

Fig. 1d. *Plaster Mask of Akhenaten, Egypt. 1372–1358* BC.

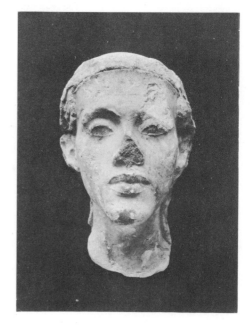

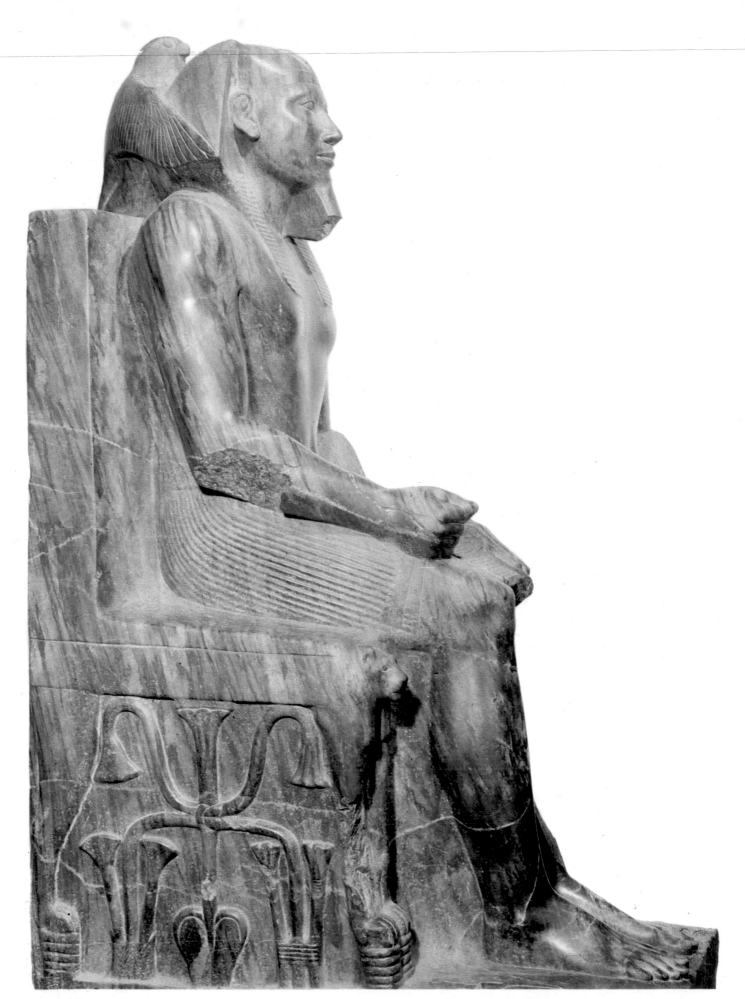

1. KHEFREN
Cairo Museum

Egypt, IVth Dynasty, 2650 BC.
Stone statue. 66 in. : 167.6 cm.

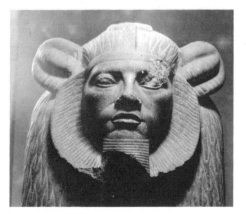

Akhenaten (Fig. 1d) betrays the exclusive interest in characterization which – at a much later date and outside Egypt – became typical of a more secular type of portraiture.

In the Old Kingdom a strange device was adopted to express the king's transcendence in a symbolic form and to proclaim it beyond the confines of either tomb or funerary temple: in Khefren's sphinx at Gizeh a leonine body was joined to a regal head. It must have deeply satisfied religious needs, for it remained long in use for royal effigies. We give one superb example from the Middle Kingdom. The lion's mane, which frames the defiant face of Amenemhet III, imparts to it a transpersonal, ferocious dignity (Fig. 1g).

As regards the wealth of statuary from the private tombs, pharaoh's subjects could not hope to emulate their incarnate god, but in a religious climate where permanence was considered the hall-mark of the divine, life-in-death became of necessity a dominant concern. On a purely personal level, however, it tended to become more fear-ridden, more wish-bound and its expression in art more trivial. A more skilful image would support the fallacy that a lasting counterfeit not only challenged oblivion but magically ensured survival. Only when primitive fear and greed were subdued and metaphysical speculation deepened, could the paradox of life-in-death become an inspiration to great artists. By adopting the canonic formula for the royal statues they could strive towards an ideal of timelessness in the image of man, as in the Middle Kingdom statue of Chertihotep in Berlin (Fig. 1a).

A brief comparison with Sumerian sculpture is illuminating, for a greater contrast with Egypt can hardly be conceived. In Sumer votive figures abound, tomb statues are absent, while there exists a striking formal difference between the 'cubic' angularity of Egyptian statuary and the Mesopotamian preference for cylindrical, or conical forms. This contrast is highly significant, for the cubic rigidity of Egyptian figures is both formally and in intention the correlate of its self-containedness, of its being the hidden image of the living dead. It is incompatible with truly expressive gesture, while Sumerian statues rarely lack the devout attitude of adoration, usually with raised or clasped hands. Votive figures, whether of common man, priest or king, were placed in the temple, in the presence of the cult statue, the epiphany of the god. A confrontation of god and man is in essence a dramatic situation in which the act of worship, not the physiognomy of the worshipper, is of prime importance. The well-known early Sumerian figures with beaked noses and pursed lips are all of a pattern. When in a later phase experiments with characterization were made these, though often remarkably lively, appear to have been haphazard, almost playful. The artist lacked not only the traditional skill of Egyptian workmanship, but the formal discipline which, for better or for worse, was demanded of images intended for the tomb as 'House of Eternity'.

The contrast is epitomized in a comparison between two roughly contemporary figures: the 'portrait' statue of the obese Prince Hemiunu (Fig. 1f) with his fine, intelligent head, and an anonymous Sumerian priest (Fig. 1e), between the utterly self-contained dignity, the immobility of the one, and the rapt expression of the other's lifted head, whose whole body, however poorly defined, takes part in a gesture of adoration.

Mrs. H. G. Frankfort

Fig. 1e. *A Priest. Square Temple of Abu, Tell Asmar, Iraq. ca. 3000* BC.

Fig. 1f. *Prince Hemiunu, Egypt. ca. 2600* BC.

Fig. 1g. *Maned Sphinx of Amenemhet III, Egypt. 1842–1797* BC.

2 A Kneeling Prisoner

Stone statuette, China. Late Eastern Chou Period, fifth to third century BC

To RECREATE in art the face of a man, a people must know more of themselves and desire to express more than the simple fact of their being. To distinguish the face of the individual man is to care for his separate being, not merely to find in him a symbolic quality to record as a testament to its living existence, but rather to perceive and apprehend an essence which does not abide in other men and which may, through the apprehension of the artist, enrich other men.

Appreciation of certain collective human patterns or qualities is expressed quite early in Chinese history. 'At first men are hard to know', wrote the philosopher Liu Shao in the third century. 'But everyone thinks that he is able to know men. Therefore when one looks at men by comparison with oneself, they may be considered knowable.' The long, introspective tradition of Chinese philosophical and moral literature reveals a concern for the perceived essence of man which is perhaps equalled in few other civilizations. Yet, throughout this long record of their thought there is a strange detachment from the individual (which among writings amounts to a classification of temperaments, emotions, abilities, usefulnesses) that reflects less concern for the individual possessor of these qualities than for the qualities themselves in their relationship to the conduct and order of life and affairs.

If it is at least partly true that in thought and literature the concern for man is an extra- or superhuman one, it is perhaps emphasized still more in art, where visual expression has been given to these attitudes toward man. In advising painters on the portrayal of men, the eleventh century critic and historian of art Kuo Jo-hsü does not admonish the artist to strive to portray the uniquely personal qualities of individuals, but rather to superimpose upon classes of humans generalized and didactic qualities suitable to a pre-existent conceptual order:

> 'In the case of Buddhist monks, the faces (should tell of) good works and practical expedients . . . In the case of outer barbarians, one must catch their mood of respectful obedience and devotion to the Flowery (Kingdom). In the case of Confucian worthies, one makes visible their reputation for loyalty, faithfulness, correct conduct, and sense of right. Warriors will naturally have a look of fierce bravery and gallant impetuousness . . . Peasants will naturally possess the very essence of unsophistication and country simplicity, plus such other (special characteristics) as respectfulness, obstinacy, joy or sorrow.'

Such attitudes reflect not merely a simplified and conventionalized checklist for the amateur painter; they reach deeply into a traditional and fundamental Chinese attitude towards man. More than a thousand years before Kuo Jo-Hsü set forth his guidelines for the analytically proper portrayal of a social order through the vehicle of art, a stone carver of the late Chou dynasty had infused into his statuette of a kneeling man no personal and revealing qualities of a unique being, but the blank terror and stoic resignation inherent in a 'social class' whose proper attitudes were not catalogued by Kuo Jo-hsü, but whose

The kneeling figure is carved from a rather soft black stone with flecks of reddish mineral. The gross structure of his face is rendered in broad concave and convex areas and only the high cheekbones, the nose and the mouth are articulated. The hair is parted in the middle and combed upward toward each side. Descending the back of the figure is an incised, double-braided pigtail, the lower end of which is concealed by the bound wrists and large, open hands. The provenance of the carving is unknown, but it probably belongs to the Late Eastern Chou period, fifth to third centuries BC.

The wall painting fragment with the portrait of a Buddhist monk is executed in ink and colour on plaster.

The bronze mask was recovered from a large tomb at the Shang Dynasty site of Hou-chia-chuang near Anyang in northern Honan province. Anyang was the last capital of the Shang dynasty, between about 1300 and 1050 BC. The mask is in the collection of the Academia Sinica at Nan-kang, Taiwan. Evidently cast in a one-piece mould, the size of the mask ($9\frac{5}{8}$ in. high), the deep orifice sockets set at upward angles and the loop above suggest that it was not designed for wearing in ritual observances, but to be suspended against a wall or some object.

Fig. 2a. A Buddhist Monk, detail from a wall painting, China. 13th or 14th century AD.

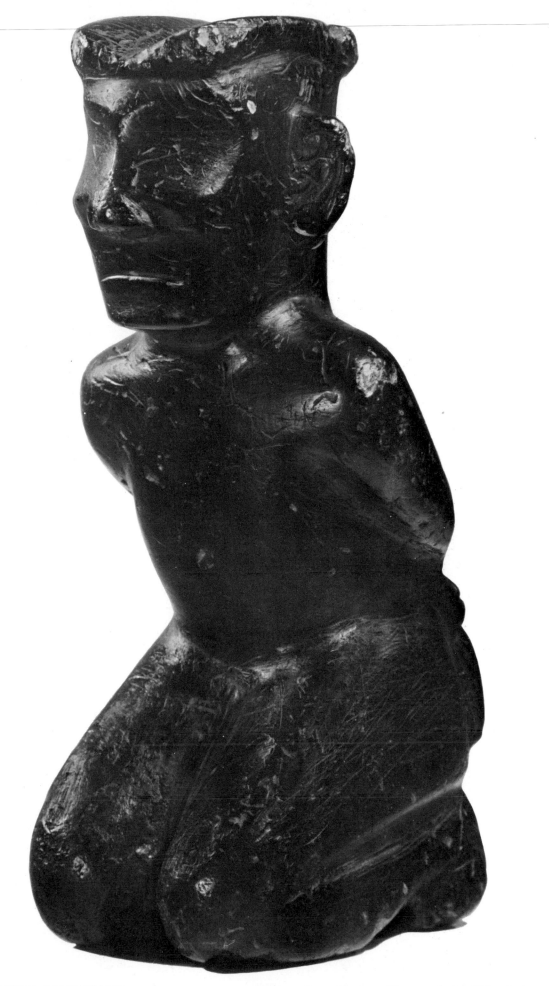

2. A KNEELING PRISONER

Art Institute of Chicago,
Mr. & Mrs. Edward Sonnenschein collection

China. Late Eastern Chou period. 5th - 3rd century BC.
Stone statuette. 7.75 × 3.5 in. : 19.6 × 8.8 cm.

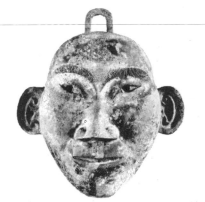

Fig. 2b. *Bronze Mask, Anyang, Shang Dynasty, China. 1300–1050 BC.*

The portrait of the Ming dynasty painter Shen Chou is a copy by the unidentified artist Yu-ch'i. Above the portrait is the original Shen Chou poem quoted here in a translation by Richard Edwards. The poem was copied on to the painting in 1622 by Wen Chia.

W.T.

Bibliography

Alfred Salmony
Archaic Chinese Jade from the Edward and Louise B. Sonnenschein Collection
Chicago, 1952

Richard Edwards
The Field of Stones: a study of the art of Shen Chou
Washington, 1962

The Study of Human Abilities, the Jen wu chih of Liu Shao
(tr J. K. Shyrock)
New Haven, 1937

Kuo Jo-Hsü's Experiences in Painting
(tr A. C. Soper)
Washington, 1951

Fig. 2c. *Portrait of Shen Chou (1427–1509 AD) by Yu-ch'i, Ming Dynasty, China.*

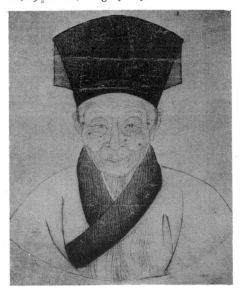

purpose or usefulness, revealed through that same system of symbolic reference, seems clear enough. Carved from an uncommon black stone, this kneeling naked man with unusual grooved headdress and with arms bound behind is perhaps an outer barbarian. He is certainly a prisoner and probably a sacrificial victim, symbolically revealing his identity in the sightless stare from two broad blank depressions in the head where a real man has eyes. He is, therefore, not a real man, but a powerfully conceived symbol of the 'faceless' being who serves all men through his meaningful sacrifice.

It is necessary only to compare this face with that of the Buddhist monk in Fig. 2a to realise to what extent the compassionate quality in man was concentrated in the eyes, and how the perceived gestures of hands bound behind, as opposed to hands clasped before, merely amplify what is granted or denied in the eyes. The face of this bearded monk, who doubtless is also a foreigner in China, is calmly and benignly radiant of the 'good works' Kuo Jo-hsü would have him reveal, and is perhaps, therefore, no less a part of the calculated patterns devised not only by the Chinese, but by all men to vouchsafe symbols in art for ideals more often concealed from one another in life.

The human face, then, in Chinese art is a sort of racial mask in which life reality does not exist, but through which concepts, social and moral forces, are suffused, either to plead the ideal harmony of a human social order or to embody and give relative human meaning to religious and spiritual forces and ideals. In such a light, perhaps, are we to view the bronze mask (Fig. 2b), which in its clear symmetry and volume and complementary linear curves fixes us with the semi-hypnotic stare born of the superhuman forces it effuses. The loop handle affixed to the crown tells us that here is no portrait of a Shang citizen, but the conceptual entity of a benign or demonic force rendered into meaningful human form.

The difference between this bronze mask and the portrait of the artist Shen Chou (Fig. 2c), executed nearly three thousand years later, is slight; only that distinction which may be drawn between the Chinese philosophical precepts of formal ritual and the formalistic convention of didactic realism in the representation of human existence distinguishes the two. Yet Shen Chou wished us to see in this portrait sketch more personal qualities. He wrote:

There are those who think
My eyes are rather small
Or my jaw too narrow;
As for me
I wouldn't know
This, nor what is lacking.

Of what use my face and eye . . .
These eighty years are
From ancestral worth!

Yet is death now
Only a wall away.

Shen Chou wished us to believe at once in the reality of his inner being and in the consequent insignificance of its decrepit external appearance. And this in the end is incumbent upon us, for the portrait is not that of a real man, but a form both superhuman and conventional from the repertoire of the artist's historically conditioned perception which hints at the reality and the ideal obscured within. It stands, as the kneeling prisoner, the Buddhist monk and the bronze mask stand, within a symbolically defined category of human beings for all men who are at first hard to know. And therefore, by our apprehension of a subtle and conventional external form we think we are able to know men who, through the natural conceit of self-comparison, may be considered knowable.

William Trousdale

3 The Benevento Head

Hellenistic bronze sculpture, Italy. Late first century BC

IN THIS PLATE we have a bronze head of a beautiful young man called *Benevento*, after the Italian town where it was discovered before being acquired by the Louvre. It depicts an athlete, and probably dates from the time of the Emperor Augustus (the end of the first century BC). It is a Greek work from the Roman period, but executed by an excellent sculptor shaped by the finest Hellenic traditions. The work's plastic quality is of a very high standard: it is directly inspired by the finest statues of athletes from the end of the fifth century BC – those of the school of the sculptor Polycletus, for example. The expression is serious, sulky even, which is surprising in an athlete! But again it reveals the serious view the Greeks had of human destiny, continually precarious and threatened. A reserved feeling of tragedy has scarcely ceased to impose itself upon their intellect and their art.

Greek art is always chiefly concerned with the exploration and representation of Man. Nothing has interested Greek artists, sculptors and painters more than the study of the human body in repose or in action. Although, at first, art was associated with a geometric conception of decoration (in the ninth and at the beginning of the eighth century BC), it soon changed, and from the latter part of the eighth century BC was devoted mainly to the representation of figurative scenes in which human beings played the chief role. This phenomenon is accounted for by the fact that Greek thought, especially religious thought, paid particular attention to the human condition.

In this representation of the human person, which plays such a large part in the artistic tradition of the Greeks, it is the face which has captured the artists' imagination most of all. The face was rightly felt to be the essential element in a man, that which is his most characteristic feature. But one must remember, nevertheless, that Greek art usually preferred to picture man *in toto*, with his body, and that the generalized practice of busts only came into being in the Roman period.

One is struck, on looking at a Greek statue, by the expression of serenity on the face. In the Archaic and Classical periods (that is, up to the end of the fourth century BC) the features are never distorted by violent feeling, save in instances of caricature or the portrayal of monsters. Even when the artist shows a man engaged in violent action (a fight, for instance), he gives his face an expression of calm; in war scenes the wounded are even seen to be smiling. It seems that the Greeks insisted on revering art as a sort of transposition or purification of reality, which aimed at elevating that reality to an ideal plane. Just as they were loathe to depict ugliness, so also were they unwilling to represent hatred or suffering. They idealized man's image so that it might approach the idea they had of their gods.

It is just this feeling we experience when in the presence of masterpieces of Archaic Greek sculpture. The Archaic *Kore* seen in Fig. 3a comes from Athens and dates from the second half of the sixth century. It is an offering to the Goddess Athene, in the form of a young girl bringing a gift (a fruit or an animal sacrifice, which has disappeared along with the right hand which must have been holding it). The young woman comes before the goddess with a confident smile, which indicates the affectionate feeling the city had for its divine patroness.

Concerning the *Benevento Head*, let us remind ourselves that the Greek bronzes did not originally possess the greenish patina that we now see, and which arouses the admiration of modern collectors. These bronzes originally appeared in the gilded gaudiness of new metal, just as if they were fresh from the mould in which they had been cast. The Greeks placed a great deal of importance upon the preservation of that shining appearance of the new metal. That is why, in the Roman period, they took such pride in gilding the bronze statues to prevent their oxidization when in contact with air, whereby they would acquire the natural patina we enjoy today. Several ancient writings allude to the cleaning of bronzes exposed to the open air, to prevent this patina forming. Studies of athletes in bronze were sought after because it was thought that the natural colour of bronze was like that of the sportsman's skin 'bronzed' by the sun. The polychrome of bronze was accentuated by the application of red copper (for the lips) and by the use of coloured materials (transparent glass or coloured stones) for the eyes. Such is the case with the *Benevento Head*.

The characteristic work of Greek art was the naked or clothed statue of a man or woman, and the exposition of a human theme. Even when this art created monsters, the latter had human faces; thus it is with Sirenus, who bears a woman's head upon a bird's body, or the sphinx, with her woman's bust and lion's body, and the centaur, who has a man's torso upon the body of a horse. The human element always prevails.

The Greeks always depicted their gods as men, more beautiful and more powerful than ordinary men. They conceived them as immortals, retaining all the characteristics of the human race, including the passions that stirred them – love and hate, joy and sorrow, anger and benevolence. It is only in that they escape death that the gods differ radically from mortals: for the rest they are merely men in an idealized form.

Since earliest times masks have been found which represent only faces; in the Mycenaen tombs of the sixteenth century BC, for instance, where a princely death-mask was recovered from a golden mask moulded to resemble the deceased.

3. THE BENEVENTO HEAD
Louvre Museum, Paris

Greek sculpture from Benevento, Italy. 1st century BC.
Bronze. 13 in. : 33 cm.

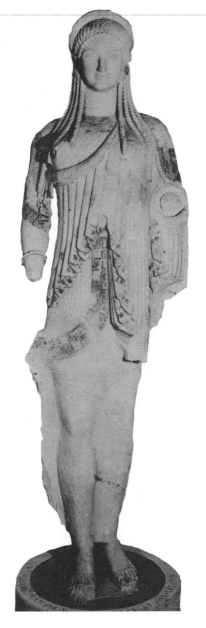

Fig. 3a. *A Kore. Greece. ca. 550–500 BC.*

It is strangely moving for us thus to discover the features, faithfully reproduced, of a great lord who ruled Mycenae three centuries before the Trojan War. Later, during the period referred to as Archaic (seventh and sixth centuries BC), vases came to be decorated by faces, viewed from the front, usually caricatured, and the figures of the gods were reduced to masks or busts.

The Rampin Head (named after the collector in whose possession it was before it reached the Louvre), and the *Kore* (in the Acropolis Museum in Athens) still have distinct traces of the polychrome which is a characteristic feature of Greek sculpture in stone or marble. All these sculptures were painted in bright colours, to heighten the realistic

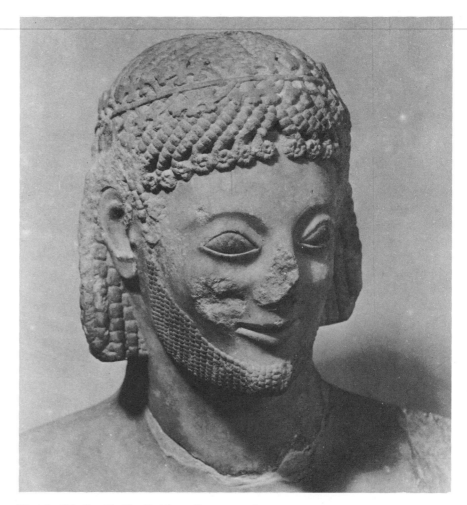

Fig. 3b. *'The Rampin Head'. Athens, Greece. ca. 560 BC.*

She is dressed in her finest attire, jewels and festal ornaments, and her hair is elaborately arranged. It is the gracious image of a society sure of itself, assured in the knowledge that it is protected by its god.

A little earlier than the *Kore*, but of the same world and satisfying the same spiritual intentions, is the bearded male head known as *The Rampin Head* (Fig. 3b). A magnificent piece of work attributed to an Athenian sculptor and dating from about 560 BC, the head originally belonged to a horseman, whose body (along with a part of his horse) was subsequently discovered in Athens and is preserved in the Acropolis Museum. Like the *Kore*, an offering to the Goddess Athene, it must have belonged to one of the noble families of the city. As it is an equestrian statue it is an indication of social position, since only nobles could afford to purchase and look after a horse. The effigy is not really a portrait. At this time, and for long afterwards, the Greeks had no intention of immortalizing the particular features of an individual, either in marble or bronze; it was enough that an inscription at the base of the statue identified the person, so that one might recall who made the offering or who was honoured by it, if it was made by someone other than the person represented. Neither the model nor the public placed any fundamental importance on the individual physical features; the statue was a symbol and a memorial, not a reproduction of a momentary reality. The features are presented in an ideal form, whose regularity is obviously very different from the person's own appearance. As for the amiable smile which plays on the lips of these figures, this is a purely conventional expression fulfilling a dual purpose; partly to express the goodwill the individual bears towards the god to whom the offering is made, and partly to remind the spectator of a certain conception of social life, which was based,

among the Greeks, upon the confident communication between men, seen as individuals, as citizens participating in the promotion of the city's well-being, even when they sincerely believed, as the Athenians did, in the need to respect hierarchy.

A somewhat different experience is offered us by the sculptors of the temple to Zeus at Olympia (Fig. 3c); it is another image of a woman no less gracious than the *Kore*, but with quite a different expression. Here, it is Athene herself, the goddess-daughter of Zeus, who is depicted in a relief, dating from about 460 BC. Her face is of a serene and regular beauty, as becomes a divinity; it is no longer lit by the archaic smile we noticed in the two preceding examples. Greek art had known, meanwhile, the ordeals which the whole Greek race had undergone in their struggles against invaders in 490 and 480–479, in order to preserve their independence. These ordeals had their effect upon art, as they had upon the people's psychology, and imbued it with that solemnity which caused the period from 490–460 BC to be called the period of the *Severe Style*. The goddess depicted on the relief is a fine example of this change in public feelings. She seems to be musing solemnly upon all the trials (the *Labours of Hercules*) that Hercules had to undergo before obtaining the reward of glory and immortality. The gods have the power of foresight and this knowledge is rarely a source of satisfaction. Such is the moral teaching of experience, and the Greeks, as the work of poets like Aeschylus and Pindar illustrates, were acutely aware of this.

François Chamoux

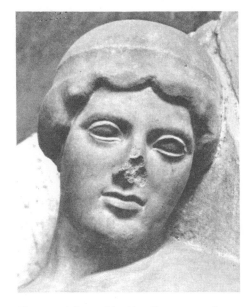

Fig. 3c. *Athene, Olympia, Greece, ca. 460* BC.

Fig. 3d. *Hermes by Praxiteles, Greece. 4th century* BC.

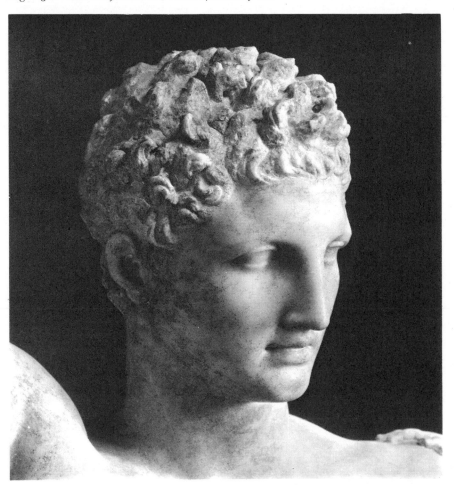

effect of facial features and to indicate details of clothing, such as embroidery. This polychrome was also used in the monumental sculptures like the relief on the temple to Zeus at Olympia, on which the *head of Athene* appears. This explains why, on this relief, the goddess's hair is so strongly stylized: the detail was indicated by the paint.

We often forget, looking at the white marble sculptures in our museums today, that they were originally coloured. The Greeks did not separate colour and form and attached a great importance to painting their statues; for example, the famous sculptor, Praxiteles, in the fourth century BC, used to give his marble statues to a celebrated painter, Nicias, to be painted. They would deplore nothing so much as to see the cold, lifeless marble that we admire today.

F.C.

Bibliography

François Chamoux
Greek Art
Pallas Liturgy of Art
New York Graphic Society, Greenwich, Connecticut, 1966

G. M. A. Richter
A Handbook of Greek Art
Phaidon Press, London, 1959

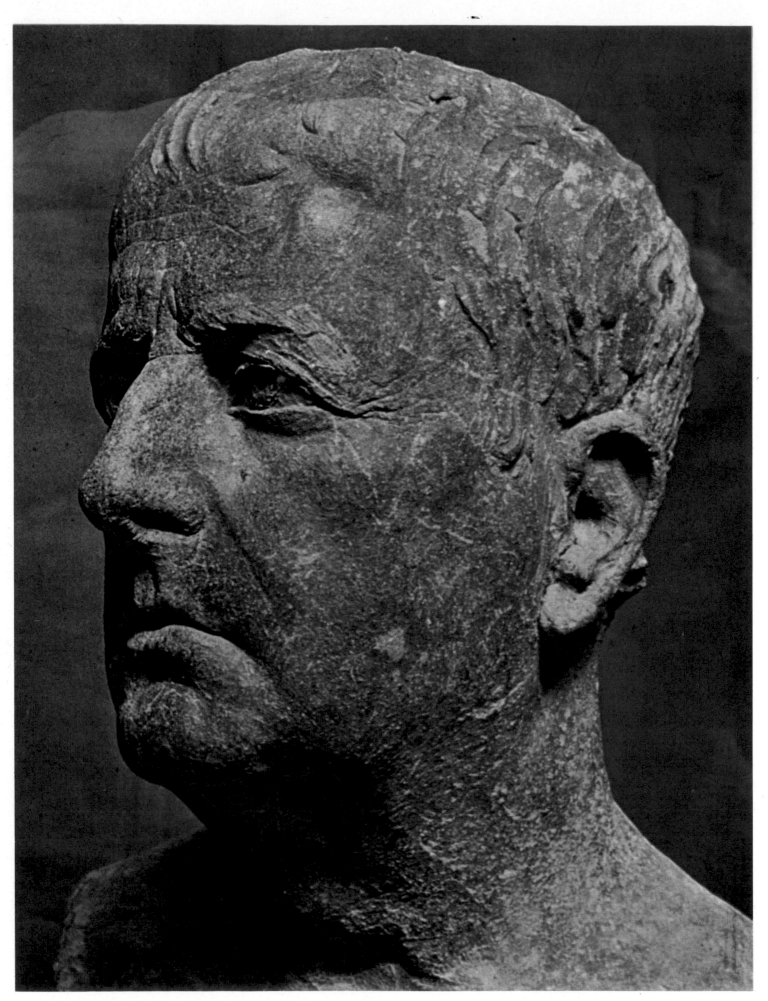

4. ROMAN PORTRAIT HEAD
Museum of Fine Arts, Boston

Roman. *ca.* 35 BC.
Terracotta sculpture. 13.8 in. : 35 cm.

Roman Portrait Head 4

Terracotta sculpture, Roman, first century BC – first century AD

Fig. 4a. *Roman Portrait Head. 1st century BC. to 1st century AD.*

Though an indigenous tradition of portraiture, and especially a convention of faithful naturalism, had a long history in the civilizations of the Italian peninsula (particularly in the funerary rituals involving death-masks and the preservation of ancestor-portraits), Hellenistic traditions, which had already permeated the art of the Etruscans, had a profound effect on Roman art with the Roman conquest of Corinth in 146 BC and their subjugation of the Greek world, from the late second century BC onwards. The earliest extant Roman portraits, from the Republican times of the first century BC, are in bronze or terracotta, painted and gilded as were the wax death-masks. This naturalist bourgeois tradition continues into the Augustan period (31 BC–68 AD) where it exists side by side with the much Hellenised imperial and aristocratic convention. (It is to the former tradition of this period, or more probably to the Republican period, that the terracotta

I N THIS EARLY terracotta head we see the various elements that go to make the Roman treatment of the human face one of the greatest achievements of portraiture in the art of the West: the frank and unremitting realism, the abiding interest in the inner spirit, in the force and power of the individual personality, are all factors that remain of primary importance throughout a tradition which saw many changes and developments in a period of four or five centuries. The fleshy intimacy of this heavy face, the ugly thrust of its prominent nose when seen in profile (Fig. 4a), the sense of age and tiredness in the wrinkles around the eyes and the loose cheeks, do not for a moment dispel the determination of its hard, set mouth, the firm bone of the chin and the fierce spirit of its staring eyes. There is an all-pervading sense of the weight and power of a familiar but impressive personality.

The naturalism of Roman portraiture is often thought to have had its origin in the Italic ritual of the death mask, funerary practices involving the use of wax, and, later, bronze and terracotta, effigies of the dead made from impressions taken from the corpse or sometimes from a living subject. No Roman household was complete without its collection of ancestor-portraits in its *atrium* or drawing room, and the ancient practice of death-masks worn by actors at funerals continued into the Christian era. No doubt the Roman portrait-sculptors' interest in expressing the individual spirit and the frequent representation in Roman portraits of such individual peculiarities as warts, wrinkles and other blemishes, derives at least in part from this indigenous Italic tradition. A more pervasive and a more profound naturalism, however, probably owed more to a scientific interest in natural phenomena which the Romans had inherited, about the latter half of the second century BC, from the Greeks. The Greeks, however, for all their interest in the human personality, had, in their sculpture, little concern for the soul; their predominant interest was in the physical structure, in form and in proportion and they produced a portraiture not of individuals but of types, idealizations of beauty, of one kind or another, and then, later, even idealizations of ugliness. The Greek discoveries no doubt provided the Romans with the technical means to fuse the Italic and Hellenistic traditions and to make their own contribution to the art of portraiture. Under Hellenistic influence, the Romans too began to carve their portrait heads in marble (Fig. 4b), often following Greek models and employing Greek master-sculptors.

The culmination of this development was reached in the mid-second century AD, especially in the so-called 'Antonine Baroque'. The mastery of new techniques and material had been completely absorbed and the Roman sculptors had gone on to extend their art to explore and reveal an inner life with an intensity and vigour never before seen. Sensing the limitations of a complete veracity to subject, they developed an Impressionistic technique, where the light and shade created by the arrangement of the face muscles, the textures of skin and flesh, the smoothness of the face and the roughness of the hair, are all ruthlessly and ingeniously exploited with 'a determination to extract every particle of physiognomic significance.' The best sculptures of this

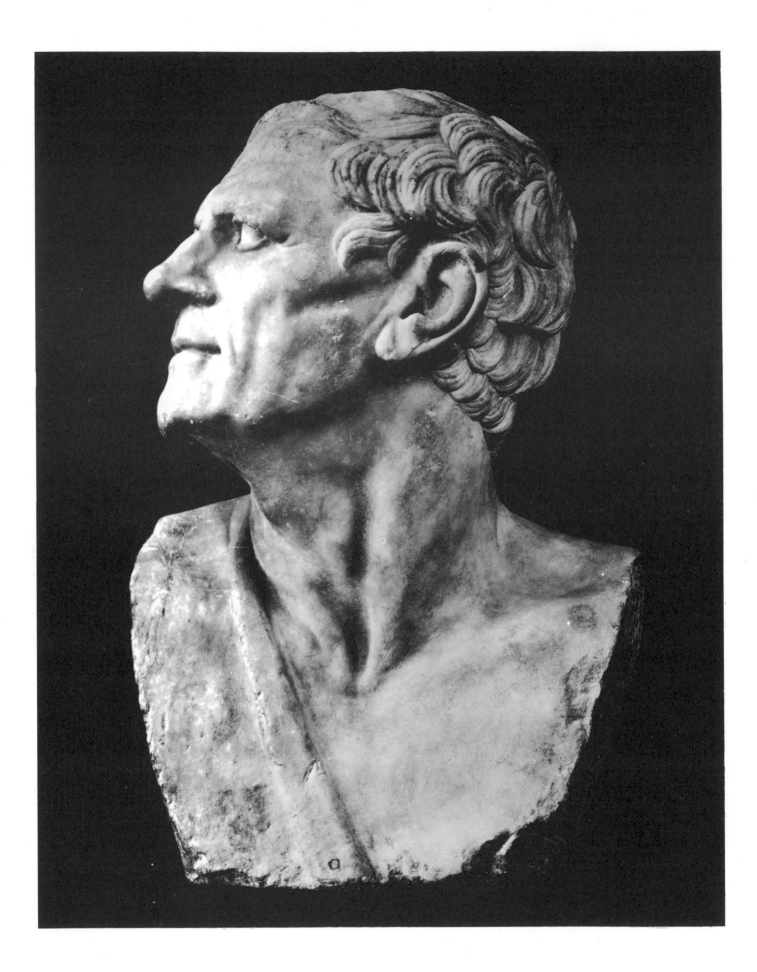

Fig. 4b. *Lisimacus, King of Thrace, Roman.*
1st century BC.

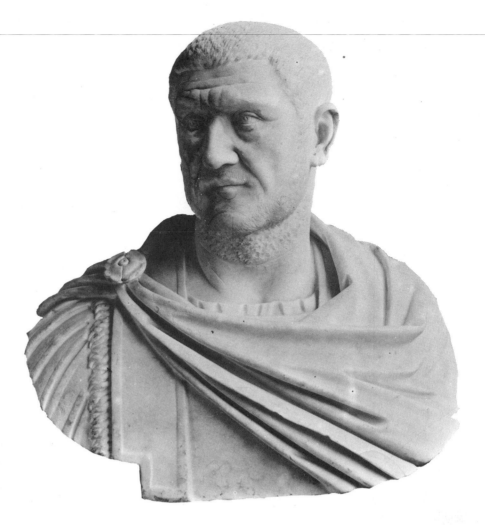

Fig. 4c. *Maximinus Thrax, Roman. 235–258 AD.*

head seen in our main plate belongs.) A real synthesis between these two traditions, which had in any case already influenced each other, takes place in the subsequent Flavian period (69–117 AD). In the latter half of this period, especially under Trajan (98–117 AD) and later under Hadrian and Marcus Aurelius (117–180 AD), the classic Hellenist trend is from time to time particularly dominant, especially in official portraits. Great changes in style and content take place continually, often from decade to decade, and several trends overlap at a given moment. The discoveries and developments of the second century are modified in the third, and by the fourth century the pure Antique tradition no longer maintains itself in the art of the new capitals, Byzantium and Ravenna; the Christian Middle Ages have begun.

Bibliography

Roger Hinks
Greek and Roman Portrait Sculpture
British Museum, London, 1935

Ludwig Goldscheider
Roman Portraits
George Allen and Unwin, London, 1940

period show a psychological insight and a technical fluency rarely surpassed by the portraiture of any other age or civilization.

With several changes of style and fashion, the prevailing style of the succeeding century seems to be a softening of the vigorous impressionism that we have already noted (Fig. 4c). The technical progression is not abandoned, but the violent movement of the spirit that is to be seen in some of the characteristic portraits of the second century is now replaced by an inward withdrawal. We see in Fig. 4c some of this sense of sadness, of strain, reflecting perhaps the changing psychology of the civilization itself. The sense of power, the emphasis on the particularities of the individual character are not lost, but are introverted, concentrated; there has been a change of emphasis.

These selected portraits give us an impression of the variety of style, mood and interest which the Roman sculptors brought to their representation of the human face and the human head. Roman portraiture was an art essentially concerned with expressing the condition of the human spirit, especially in certain moods of power and authority, but it did this without distorting or departing from the sometimes unpleasant facts of the real appearance or character of the individual portrayed. Its achievement in portraiture of this kind can only be compared with the art of the European Renaissance which itself, as we all know, owed so much to the rediscovery of the Classical tradition.

*Roger Hinks**

**The Editors have completed this text, which remained unfinished at the time of the Author's death.*

25

5 Portrait of a Young Girl

Coptic Painting on wood from Fayum, Egypt. Third century

AT THE END of the last century hundreds of mummy-portraits were discovered in several sites in the Egyptian oasis of Fayum. The importance of these fascinating and often beautiful works – commonly known as Fayum portraits – is manifold. They portray the human features with a vividness and verisimilitude that are seldom found in European art to the same extent. They are also the only surviving authentic examples of the lost panel paintings of classical antiquity. Moreover – and this point is of the utmost interest – they reveal the formal principles of an aesthetic approach which stems from a new attitude to life and a new conception of the universe; they convey a specific message. It should also be emphasized that mummy-portraits must be seen not in isolation, but in relation to the contemporary spiritual values. They form, in fact, one vehicle for the expression of a distinctive attitude to the general problems of life, one which engendered not only a novel way of representing human beings, but also a new genre of art.

The vital question about the meaning of the portraits – the question of their spiritual and religious implication – has never been asked. Certain external facts seemed to suggest that mummy-portraits and death-masks were related. Each of them was placed in front of the dead man's face; the portraits shared their realism with the Roman death-masks, the *imagines majorum*, and, like them, were kept in the *atrium* of the house. Thus, mummy-portraits had been tacitly accepted as a variation of the death-mask, which reached the highest degree of realism in the painted portraits. This is, however, debatable, since the magic function of the mask was to act as a substitute for the body, doomed to destruction, a counterfeit and simulacrum in the truest sense of the word. This magic purpose demanded sculptural representation. The mask had to belong to the same spatial reality as the body which it was to replace. This could not be achieved, however, by a two-dimensional portrait. Can one therefore assume that the projection or translation into the plane, briefly the flat portrait, implies a higher degree of naturalism than sculpture? Is it really possible to assert that a painted likeness is closer to nature than a carved mask, however schematic the latter may be? Surely, a society which does not think in formal and aesthetic categories, but in primitive concepts, is likely to find a sculpture closer to nature and more real than a rendering in the flat.

This change of dimension, this reduction of the space-filling mask to the two-dimensional painting, reveals not only a formal and aesthetic change, but a phenomenon of basic importance for the spiritual development. The change is not only one of style; this new dimension of form, the 'non-sculptural', if one may coin a phrase, is deeply rooted in the new dimension of the spirit which Christianity brought about, with its fundamental change in the evaluation of life and its servant, the body.

The unusually strong, even fascinating, effect which these portraits have is gained not only by the intense accuracy of human representation, the truth to reality, the extraordinarily large eyes with their visionary gaze, but, above all, by a well-defined composition which

In 1899 Theodor Graf, on a tour of the European capitals, displayed to a dazzled and enchanted public an exhibition of about a hundred portraits painted on wood, which he had bought from Bedouins at Fayum in Egypt. These had originally been attached to the faces of mummies. (The effect produced by these paintings must have been particularly striking, as many of them, in style (fattura) as well as in colour, were startlingly similar to Impressionist paintings, then still hotly discussed.) When it was suggested that the portraits might be forgeries the English archaeologist Flinders Petrie went out to Fayum to look for further examples.

During two seasons of excavation he found some 150 such portraits still *in situ*, whereby the authenticity of Graf's portraits was established. As to the dating of the mummy-portraits, we can say in conclusion that they start approximately at the beginning of our era and end with the edict of Theodosius (392) who, by prohibiting the embalming of bodies, caused them gradually to

Fig. 5a. *Portrait of a Young Woman, Fayum. Egypt. 2nd century* AD.

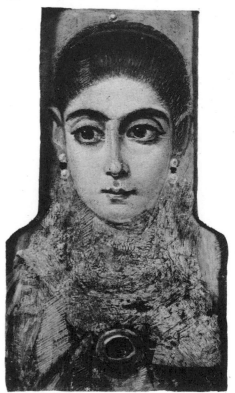

5. PORTRAIT OF A YOUNG GIRL
Stadtische Gallery, Frankfurt

Egypt, 3rd century AD.
Painting on wood. 13¾ × 8¹⁄₁₆ in. : 35 × 20.5 cm.

disappear; and that, in principle, the technically accomplished, light and impressionistic pictures are the earlier ones which, in the course of orientalization, yield to the later, darker, more expressive kind. But, just as in textiles, these two styles do not necessarily imply a *sequence in time*; it is possible that they *co-existed* in different art centres and in different social classes.

H.Z.

Translated from the German by F. M. Godfrey

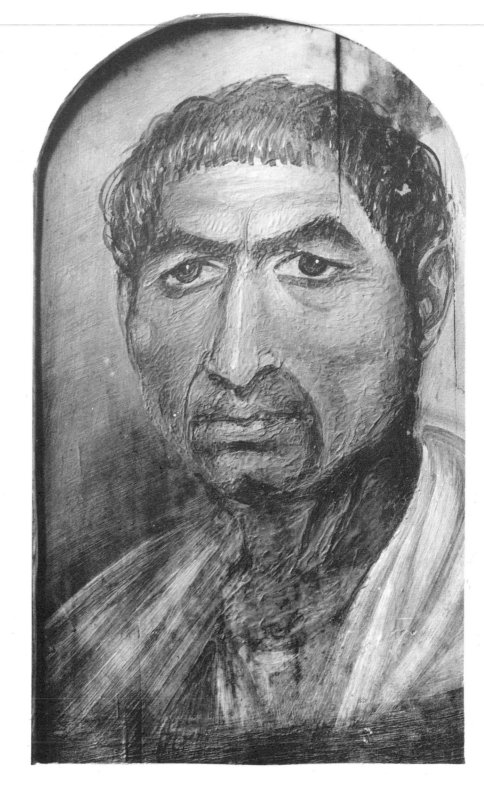

Fig. 5b. *Portrait of a Man. Hawara, Egypt. ca. 150* AD.

never changes. The faces with their rounded cheeks, the spherical eyes, the columnar neck are modelled by means of light and by the shadows they cast. But however much the figures are conceived in the round, the background, devoid of all spatial depth offers no correspondence. The plane before which the painted figures appear has no equivalent in the world of reality: it is, so to speak, the 'Nothingness' of ethereal space. Even though iconographically it can be interpreted as Heaven or as the Light of Paradise, creating a meaningful relationship with the represented persons, looked at as pure form the contradiction between rounded bodies and plane remains, and it is this which des-

27

troys the volume. A kind of volume comes into being which appears corporeal and incorporeal at the same time, a new substance which lacks all density.

There exists in the portraits a contradiction between the relentless realism and truthfulness of the representation of the figures and their immobility which places them outside time and space. If, on the one hand, the impression is created that the model is the dominant and principal value, it is at once removed by a higher will from its ambience and transferred to another, where abstract laws of composition rule, such as frontality, symmetry and composition on one plane: these, and the ethereal space of the background, estrange the model from its natural sphere of life. In spite of all physiognomic variety and individual as well as ethnical differences, all the individual figures are united in a higher, supra-natural order and subjected to a common law, which deprives them of their uniqueness and makes them equal with one another. Motionless and impassive, as if frozen in timeless vision, they offer the highest degree of solemn formalism. The formal principle with the greatest power of expression is their frontality. All other formal values, like axial symmetry and two-dimensional composition are subordinate to it. The figures appear at all times, and quite exclusively, in the same frontal attitude, and the fascinating spell which no spectator can escape – the lofty pathos and saintly dignity which endow these portraits with religious significance – emanate from this frontality, this face-to-face and eye-to-eye attitude, which turns into a relationship between the 'I' and the 'Thou', the person represented and the beholder.

And just as the change in the realm of art lay in the new relationship between the person represented and the beholder, so in the religious realm it concerns the relationship between the believer and his God.

As the death-masks were created to preserve man's physical existence in a 'Beyond' which lacked all transcendental character, so the mummy-portraits aimed at rendering the imperishable spiritual essence of man.

Hilde Zaloscer

Fig. 5c. *Portrait of a Young Man, Egypt. 4th century* AD.

Bibliography

Hilde Zaloscer
The Mummy-Portrait: an Interpretation.
Apollo, No. 24 (New Series), Vol. LXXIX
February, 1964. London

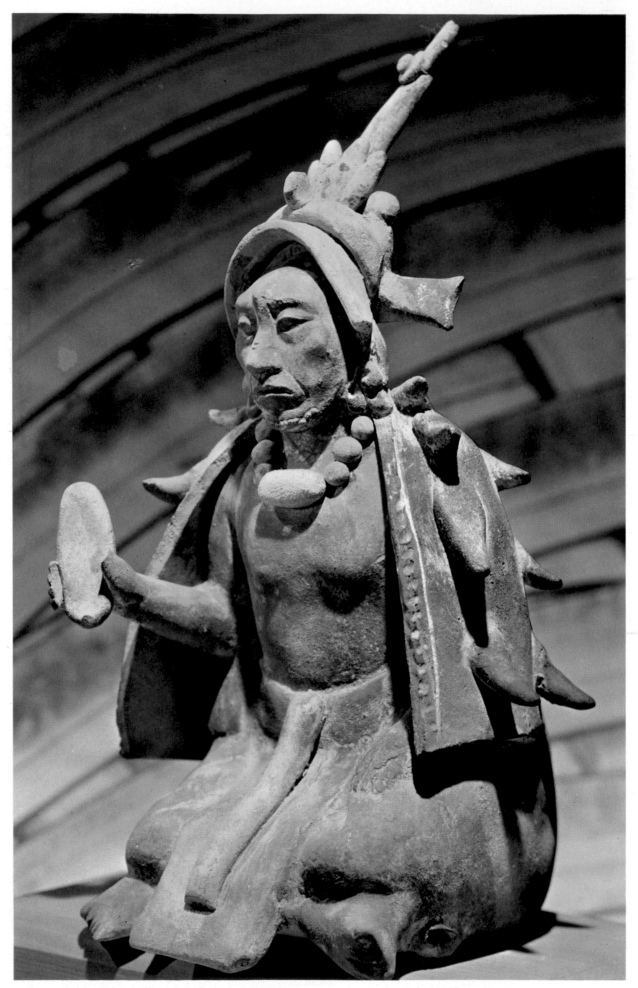

6. AN ANTHROPOMORPHIC WHISTLE Mexico. 3rd - 10th century.
Dumbarton Oaks, Washington Terracotta figurine. 8.5 in. : 20.6 cm.

An Anthropomorphic Whistle 6

Mayan terracotta figurine, State of Campeche, Mexico, Jaina Island Style
Classic Mayan Period, third–tenth century

Man's cultural development in the Americas stretches over a period of several thousand years, and its various epochs do not always correspond to those of the Old World. The Classic Mayan epoch (third–tenth century AD) unfolds with the complete development of steles, on which hieroglyphics and signs of a definitely formed calendar appear. This is the most glorious period of this civilization.

The Mayan peoples occupied a vast area which comprised the states of Campeche, Yucatan, Chiapas, Tabasco and Quintana Roo in modern Mexico, all the territory in Belize and Guatemala, as well as certain parts of the Honduras and Salvador. The Mayan linguistic family is the most homogeneous one in the whole of Central America and still exists today, geographically grouped.

The bust of a woman (Fig. 6c) in blue jadeite, a fragment of what was probably a full-length statue, belongs to the finest period of *Olmec* culture. Freely executed, of a realism and dynamism rare in Pre-Columbian civilizations, Olmec sculpture is informed by a simple symbolism concerned with portraying the human body above anything else. The Olmec style (800–400 BC) refers to the art of a period before the Mayans. One of its principal archaeological centres is La Venta. Certain Olmec jades are among the most beautiful known in the world.

F.G.

Bibliography

Fernando Gamboa
Catalogue: 'Chefs d'œuvre de l'Art mexicain'
Paris, 1962

S. K. Lothrop
Pre-Columbian Art
Phaidon Press, London, 1959
Catalogue: 'Chefs d'œuvre du Musée de l'Homme'
Paris, 1965

THE HOLLOW pottery-figurine reproduced here is also a whistle, in which the left knee is the mouth-piece. It is in the shape of a human figure sitting cross-legged, holding an oval object in his hand. He is wearing the customary belt and apron underneath a short cloak covered with spikes. The necklace is made of balls and a cylinder. The chin is tattooed and the head-dress is a decorated hood ending in a long point.

Mayan work in stucco and terracotta represents not only the physical appearance of the Mayan people but also the social rank of each individual, his mode of dress and his expressions. The noble bearing of chieftains seated on their thrones, the hieratic majesty of their priests, the referee at *pelota* games (a kind of ball-game played by the Mayans), the priestesses, the deformed beings and the common people were subjects extremely popular with the Mayan artists and were executed with infinite variations, even in the whistle-figures or bells,

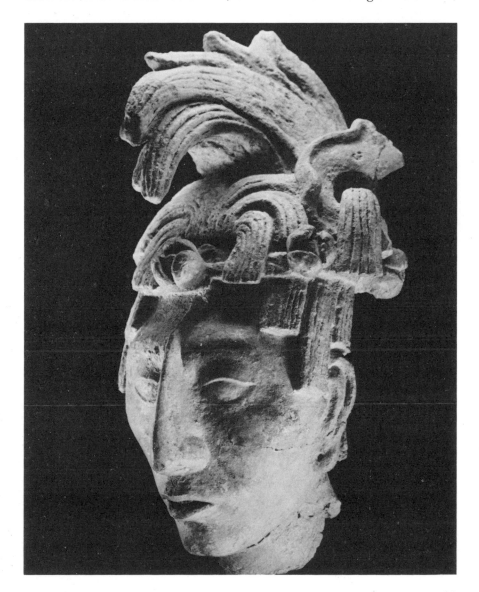

Fig. 6a. *Head of a Sacrificial Warrior, Palanqua Mexico. Classic Mayan Period 3rd–10th century AD.*

and the Jaina dolls which could be taken to pieces. The fans, copal sachets, skirts, sandals, bucklers, bracelets, necklaces and belts all give us information about Mayan clothes and ornaments, in addition to the immense documentary interest of the animal representations which also appear on them.

Fig. 6a depicts the head of a sacrificial warrior, adorned with feathers and flowers. The nose is enlarged, giving the impression of the Quatzal bird, the Mayan aesthetic ideal. A part of a rich offering, this head was discovered under the tomb of an important personage, in the Temple of Warriors at Palanqua, in the State of Chiapas. It appears to have come from a decapitated statue. The decapitation sacrifice, a very ancient rite in Pre-Columbian Mexico, gave the sacrificial victim promise of deification and transmutation into a star. The discovery of the tomb, underneath which this head was found, revealed that the Mexican pyramids were not only bases for the temples, but were also burial-places.

In the stucco head seen in Fig. 6b, also from Palanqua, the pronounced slope of the forehead reproduces the effects of an artificial cranial deformity practised by the Mayans. The crest which continues the line of the nose indicates the position of a jade ornament worn by persons of importance. The back of the head is flat and it was probably fixed against a wall as a decoration on the outside of a building.

It is in Palanqua, most certainly, that the Mayans gave the fullest proof of their talents as modellers. The human heads found in the Temple of Inscriptions and at El Palacio attain a rare dignity and emotional depth.

Fernando Gamboa

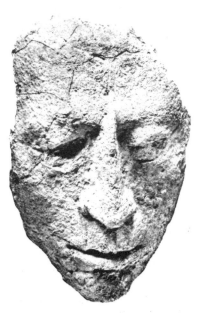

Fig. 6b. *Stucco Head, Palanqua, Mexico. Classic Mayan Period, 3rd–10th century* AD.

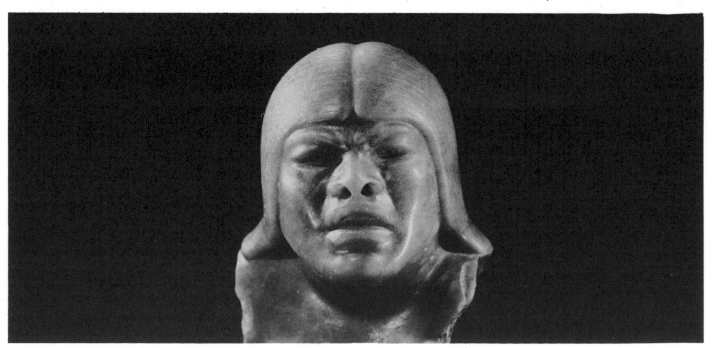

Fig. 6c. *Bust of a Woman. Olmec Style, Mexico. 800–400* BC.

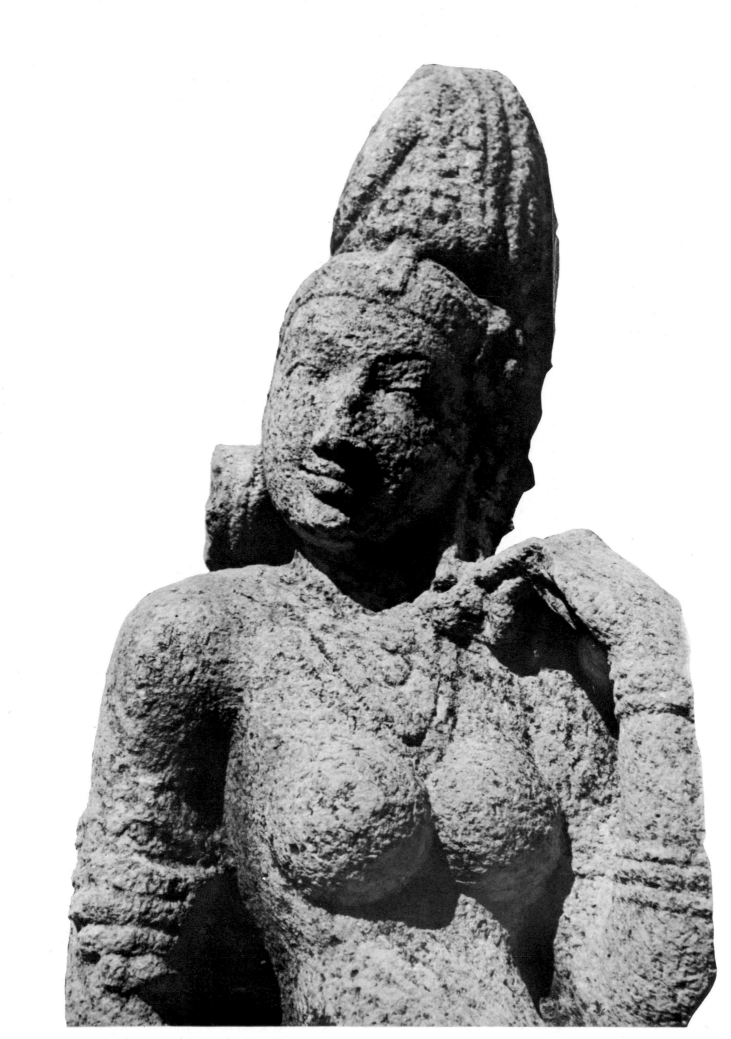

7. PORTRAIT OF A QUEEN Mamallapuram, India. *ca.* 7th century.
Stone relief (detail).

Portrait of a Queen 7

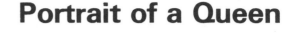

Detail from a Pallava relief carving, Mamallapuram India. Seventh century

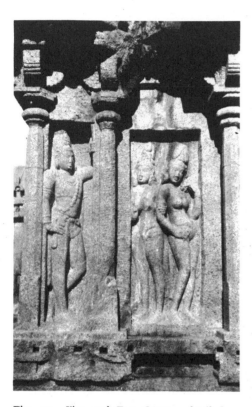

Fig. 7a. *King and Two Queens, detail from the facade of the Arjuna Ratha, Mamallapuram, India. 7th century* AD.

The Pallavas, one of the great dynasties of Southern India, ruled over a large empire in the south-east, from about the sixth to the tenth century AD. The inheritors of a tradition that led back to Sanchi,* they were amongst the first to develop the characteristic form of the stone-built Hindu tower temple. The earliest of their free-standing temples (as opposed to the excavated cave-temples) which have survived are a series of monumental architectural models, known today as *rathas* (Fig. 7b), replicas of actual structural temples, carved out of great outcrops of rock at the ancient port of Mamallapuram. Executed in the reign of King Narasimhavarman I Mamalla (630–668 AD), the work on the temples continued throughout the seventh century, and some of the sculptural detail on the *rathas*, from one of which our main plate

Fig. 7b. *The Rathas. Mamallapuram. India. 7th century* AD.

THIS PORTRAIT of a queen is a detail from a group of royal 'donors' or patrons, showing a king and his two queens (Fig. 7a), from one of a series of free-standing temples cut out of a great ridge of rock at Mamallapuram in Southern India. The permanent architectural materials, such as brick and stone, were considered a sacred medium; the placing of these royal portraits on the outer walls of a temple together with gods and demi-gods carries with it the implication that these kings and queens were closely associated with divinity. And yet, as with a great deal of Indian sculpture, there is a very palpable human presence in this figure of a young queen, with her soft, smiling face and her supple, voluptuous body. That the portrait bears any resemblance to its subject is unlikely and, in any case, can scarcely be verified today. A realistic likeness is not unknown in Indian portraiture, as literary evidence proves, but the only extant portraits which certainly reproduce the exact likeness of their subjects are fairly recent examples from the seventeenth century onwards.

It is generally true of Indian portrait statues that, as Coomaraswamy has remarked, they 'ought to be called effigies rather than portraits in the ordinary sense of the word – they do, as a rule, reproduce the details of contemporary costume, but as representations they are types rather than individualized portraits'. The modern interest in personality turns on the especial uniqueness of the individual; to the Hindu mind, preoccupied with reincarnation, where the individual soul is constantly elevating or depressing its metaphysical potential with each rebirth, individuality is only the means by which the personality is striving towards some absolute end. Thus, while portraiture as we understand it today is a manipulation of form towards an interpretation of the nature of a particular subject, Indian portraiture works in the opposite direction; it interprets its subject in order to idealize it. Its realism, the conviction it carries, is its revelation of essential experience in the most tangible plastic terms, evolved by a tradition long pre-occupied with the human form. The art of the Indian sculptor and painter is to give those traditional conceptions an individual vitality and a relevance to the context in which they exist, to render an idealized experience concrete in time and space.

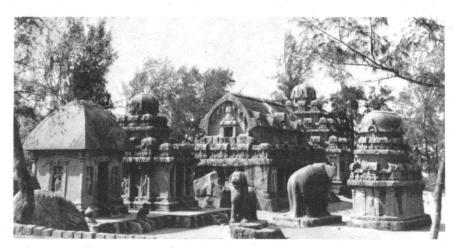

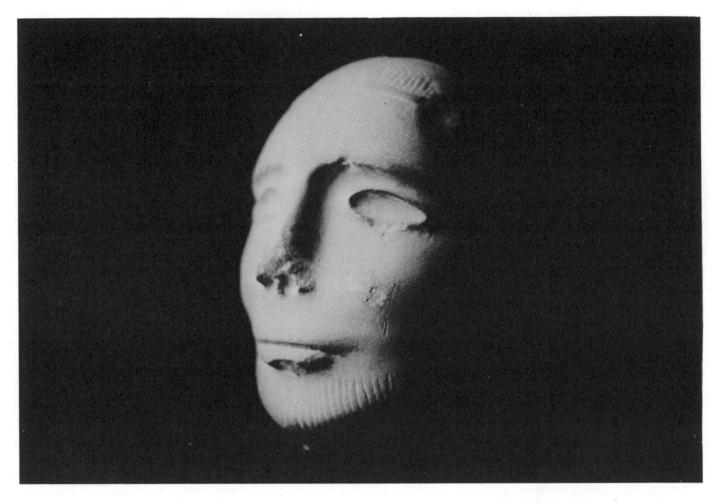

Fig. 7c. *Head of a Bearded Man, Indus Valley, India. ca. 2000 BC.*

Indian art, from its earliest beginnings in the Indus Valley (2500–1500 BC), has shown a predilection for the human face (Fig. 7c) and the human body. The art of the historical period (sixth century BC onwards), probably not quite as unconnected with the ancient culture of the Indus Valley as it may seem to be, began to show an interest in the human form in the last five or six centuries BC. Divinity, once represented by the most sophisticated or the most primitive symbols, was first personified in literature and was then expressed in human or superhuman form in sculpture and painting. This development was paralleled by an art of royal portraiture; among the earliest extant Indian sculptures of the historical period is a representation of a king as Universal Ruler, equipped with the archaic symbols of his power (*ca.* first century BC); the earliest representations of female figures are images of *yakshis* or tree-spirits, also from the first century BC, who carry with them those attributes of abundance, fertility and a sensuous vitality which were to remain the ideals of female beauty throughout the Indian tradition.

Sēnake Bandaranayake

is taken, was probably completed during the reigns of Mamalla's immediate successors. Pallava art and architecture had a far-reaching effect on the civilizations of South-East Asia, such as that of the Khmer (Plate 8).

* See *Man through his Art*, Vol. 3, *Man and Animal*, Plate 8.

Bibliography

T. G. Aravamuthan
Portrait Sculpture in South India
The India Society, London, 1931

Benjamin Rowland
The Art and Architecture of India
Pelican History of Art
Penguin Books, Harmondsworth.
Middlesex, 1953

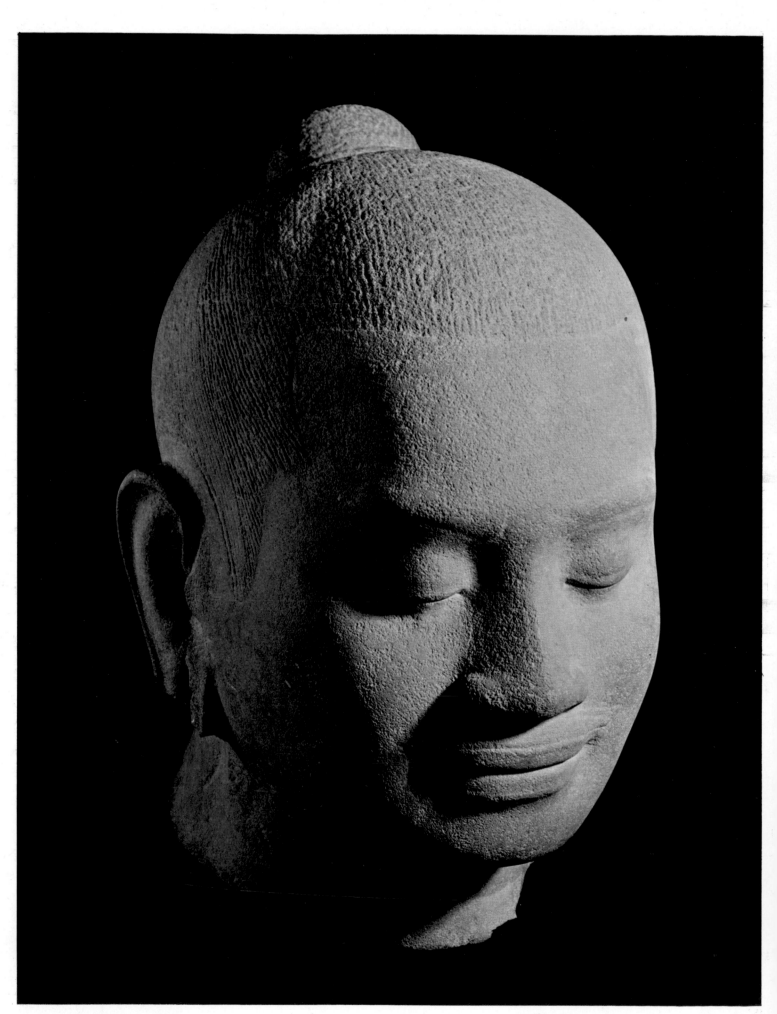

8. JAYAVARMAN VII
National Museum, Phnom Penh, Cambodia

Portrait sculpture. Angkor, Cambodia. *ca.* late 12th century.
Stone. 16.1 in. : 41 cm.

Jayavarman VII 8

Stone portrait sculpture, Khmer-Bayon style, Angkor, Cambodia
c. late twelfth century

The legitimate heir to the Khmer throne, Jayavarman VII, had spent a great part of his life in exile near Angkor, allowing a rival claimant and then an usurper to occupy his father's throne. It was only the invasion of Angkor that brought him out of his seeming passivity, and then after a series of decisive battles he drove out the invaders and ascended the throne in 1181, amidst the ruins of a devastated capital. A brilliant but a ruthless general, he set about avenging his country, not only attacking his erstwhile enemies, but his allies and neighbours too. He annexed a great part of the Indochinese peninsula and for a time it seemed as if he would bring all Indochina under his sway.

Khmer art has its beginnings as a distinct tradition from the seventh century AD. In the latter half of the sixth century, the kingdom of Chen-la, the nuclear state in the middle reaches of the Mekong River from which the Khmer Empire originates, annexed the ancient, Indianized kingdom of Funan, the centre of a once powerful empire on the coastal plain of what is now modern Cambodia. From this union between a virile mountain race and an ancient civilization of the river delta sprang the history and the art of the

Fig. 8a. *The Four Faced Tower, Bayon Temple, Angkor Thom. Cambodia. ca. 1200 AD.*

JAYAVARMAN VII was the last of the great kings of the Khmers, who in a short space of six centuries had created an art and an architecture which in the scale and quality of its achievement could rival that of any of the great European or Asian civilizations. Khmer civilization had reached its apotheosis in the great temple of Angkor Vat*. In the aftermath of this great achievement, in the latter half of the twelfth century, the Khmer Empire collapsed and the sacred city of Angkor fell to invaders. It seemed as if at its most glorious moment Angkor was to come to an end. This was soon to be the fate of the Khmer Empire but, in a dying gasp as it were, it was still to enjoy several more decades of power and artistic productivity under its last god-king Jayavarman VII.

Jayavarman was over sixty years old when he ascended the throne and his reign lasted for nearly thirty-eight years of ceaseless activity. This portrait of him was probably done at the time of his accession and is thought to be an authentic likeness of the king. The head is certainly a most extraordinary feat of portraiture. Behind its gently closed lids and tightly drawn smile is the sense of an awe-inspiring personality, a great king, to whose power and determination, strength of will and authority it forms a most fitting testament.

The distinctive treatment of the face in the Khmer sculpture of Cambodia is one of the most familiar stylistic conventions of Asian art. The tight-skinned, smooth-boned faces with their soft, sensuous lips and the attenuated line of the mouth are easily recognizable characteristics which continue throughout Khmer art, from its beginnings in the seventh century AD to the decay of the Khmer tradition at the end of Jayavarman's reign in the thirteenth century. Even with the abandonment of the Khmer tradition of carving in stone, the Siamese-inspired wood sculpture of later Cambodian art (Fig. 8b) still retains some traces of Khmer style. Contained though this style may seem to be within the limits of a convention, the portrait of the Khmer King Jayavarman VII and the other Khmer sculptures illustrated here show us the variety of character and mood, the insight into the individual personality that Khmer portraiture achieves.

Jayavarman extended the Khmer Empire far beyond the limits it had ever covered before, and not merely content with controlling a large empire, he set out to restore the damage and destruction that war and neglect had brought to his country. He repaired and improved the intricate system of lakes and canals on which the Khmer economy depended; he built hospitals for the sick and resthouses for pilgrims. Restless about the welfare of his people, among his many inscriptions we find this declaration:

The ills that flesh is heir to became in him a spiritual ill all the harder to bear because it is the public sorrow which makes the grief of kings, and not private afflictions.

He repaired the ruined temples, remodelled others and, within the first decade of his reign, built four great temple-monasteries, to the memory of his parents, his tutor and one of his sons killed in battle.

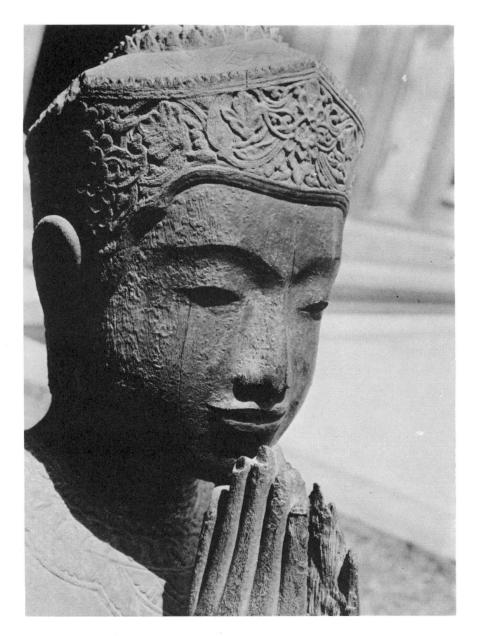

Fig. 8b. *A Buddhist Devotee (detail), Angkor-Vat, Cambodia. ca. 16th century* AD.

Khmers. In a distant corner of Asia, the Khmers developed, through a succession of styles, a magnificent art and architecture. Khmer civilization ended, with the reign of Jayavarman VII (*ca.* 1181–1219 AD), as rapidly as it began; after a tremendous effort, in a period of little more than six centuries it had exhausted itself completely. The origins of the early Khmer styles are obscure; it certainly owed something to the art of Funan; the Indian influence (already present in Funanese art) and especially that of the Pallavas (Plate 7), certainly played an important part; but, finally, it was the original genius of the Khmers themselves that created their distinctive styles of art and architecture.

*See *Man through his Art*, Vol. 1, *War and Peace*, Plate 8.

Bibliography

Bernard Philippe Groslier
Indochina, Art in the Melting-Pot of Races
Methuen, London, 1962

Madeleine Giteau
Khmer Sculpture and the Angkor Civilization
Thames and Hudson, London, 1965

Fig. 8c. *Tower in the shape of Four Human Heads, Angkor Thom, Cambodia. ca. 1200* AD.

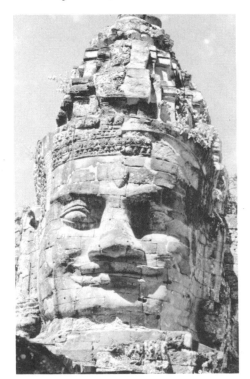

He completely redesigned the city of Angkor Thom, fortifying it with an earth rampart and a moat ten miles long and more than a hundred yards wide. A Buddhist, unlike his mainly Hindu predecessors, and a ruler most attentive to the needs of his people and his responsibilities to his religion, he was no less avid for his own personal glory and immortality. He had statues of himself placed in many of the important temples and built his own *temple-mountain*, the Bayon, set at the very centre of the royal city. In this vast edifice, with its towers in the shape of human faces (Fig. 8a) and its great galleries of sculptured reliefs, he had himself identified with its presiding divinity, 'Buddha the King', in keeping with Khmer practice. The surrounding chapels enshrined statues of the nobles and the officials of the realm. The palace itself stood a little to the north of the Bayon. Several other temples, chapels, hospitals and monasteries were built or restored and the whole complex was joined together in an intricate symmetry by ponds, canals and carved stone terraces. The main gates leading to this vast city were surmounted by four-faced towers (Fig. 8c) similar to that of the Bayon. The whole city became not only a magnificent achievement of engineering and architecture but one of the most impressive feats of planning that the world had ever seen.

Anil de Silva

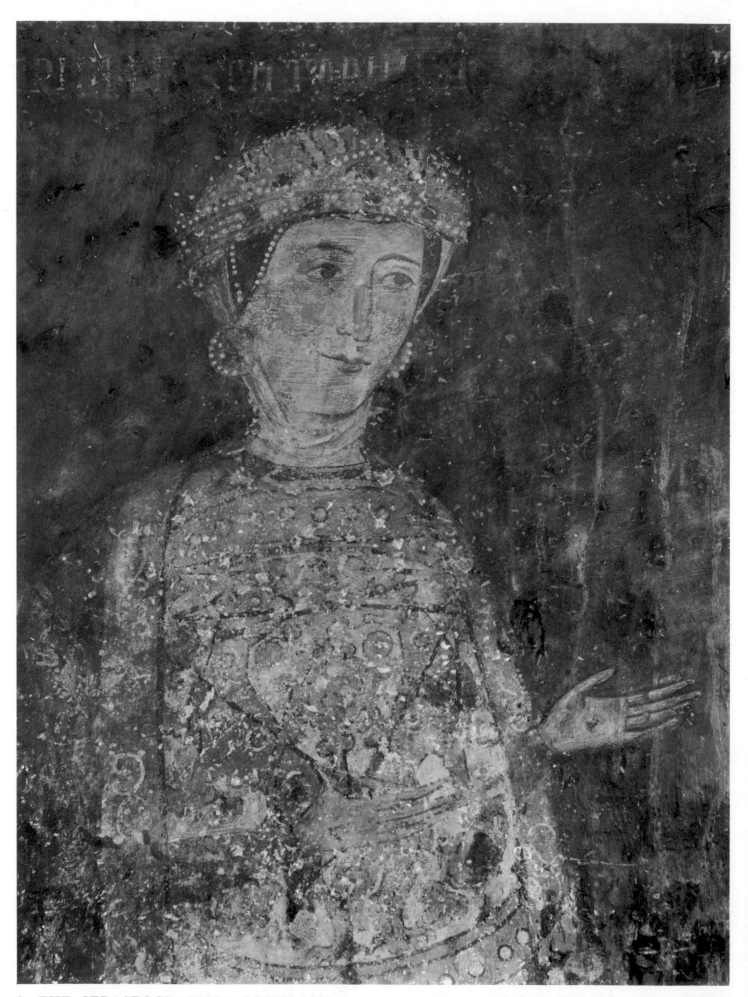

9. THE SEBASTOCRATISSA DESISLAVA
Church of Boiana, Sofia, Bulgaria, 1259

Tempera painting. 66 × 49 in. : 168 × 125 cm.

The Sebastocratissa Desislava 9

Detail from a fresco painting, in the Church of Boiana, Sofia, Bulgaria, 1259

The Boiana murals were executed by an unknown artist of the 'School of Trnowo', so-called after the capital of the Bulgarian kingdom, where a highly cultured society had established itself around the court. Since the early eleventh century, Bulgarian life had been conditioned by Byzantine orthodoxy, both religious and secular, and the Byzantine tradition had imposed its iconography and stereotyped forms and concepts on Bulgarian art. This influence, however, was slowly diluted by the re-emergence of older provincial traditions and by new influences from the pagan North and later from the West, which since the Crusader conquest of Constantinople in 1204 had become a direct neighbour to Bulgaria. Yet, the Boiana frescos are still 'Byzantine' in the truest sense of the word: the portraits of the Bulgarian rulers are a designed compendium of court rules and etiquette; every detail of their clothes and ornaments has an iconographic value, and no attribute of rank and position is omitted. But the faces that look out at us from under these heavily jewelled crowns are extremely individualistic and differ completely from the stereotyped representations of Byzantine emperors. The technique of painting is also new. Boiana is the first known *fresco a secco*, a technique using tempera colours containing egg-yolk, which enabled the artist to use a wider range of colours than was possible before and to render especially darker shades like the blue-black background to the Desislava portrait.

The Desislava portrait shows very clearly the Western influences on the Boiana paintings. This is not surprising if we consider the conversion to Roman Catholicism, the marriage alliance between Desislava's daughter and the Latin Emperor of Constantinople, Henry of Flanders, and the thriving trade between Bulgaria and Italy. These influences are particularly noticeable in the treatment of the face and of posture. Desislava's head, with the crown (or 'mistrella striata') set over a little bonnet and the transparent scarf mischievously twisted around the chin in a manner more playful than useful, remind us of certain Gothic sculptures such as the statues from Naumburg, Germany. Again the shy gesture with which she holds her mantle is character-

THIS GENTLE and gracious head is a detail from a series of wall-paintings in the vestibule of the church at Boiana, a little village five miles south of the present Bulgarian capital, Sofia. They were commissioned in 1259 by the new Bulgarian Czar, Constantine Tich (1259–1277 AD), and include portraits of the new Czar himself and his wife, and of his predecessors, the Sebastocrator (a ruler of a lower rank than a Czar), Kalojohannes Asen (1197–1207 AD) and his wife the Sebastocratissa Desislava, who had founded the church at the beginning of the century and were buried there. These life-size portraits are amongst the earliest (it may well be that they are indeed the first) realistic or naturalistic portraits in European art since Classical times. Painted some eight years before the birth of the great Italian master, Giotto, they remind us that the growth of Humanism had begun in the Christian world of the Eastern Mediterranean at about the same time as it did in the West. All four portraits have been painted 'after nature' – the portraits of Desislava and Kalojohannes are copied from an earlier painting, while the Czar and the Czarina were themselves the models for their portraits; but if they convey to us the physical likeness of the Bulgarian rulers, they nevertheless tend to embellish their characters.

A pagan princess converted to Christianity, Desislava helped her husband to secure his political position with the aid of her martial people, the last pagan and nomadic tribe dwelling on the western shores of the Black Sea. Kalojohannes was the youngest of the three brothers Asen, who at the end of the twelfth century had liberated Bulgaria from the imperial Byzantine yoke. He ascended the throne in 1197 after the murder of his two brothers and, in order to secure his throne, in 1204 he asked for and accepted a crown from Pope Innocent III, promising in return to bring his country over to the Roman Church and to relinquish the Orthodox Eastern faith. Kalojohannes was noted for his courage, cruelty, dishonesty and cunning; Desislava matched him in his ambition and his unrestrained passions. She was renowned for her sensuality and her frivolity and our informed eye may well find confirmation of this in her portrait; she appears there as a lady who knows well how to put her charms in the right light. We are, then, not surprised to hear from her chroniclers that she was said to be a second Potiphar's wife. In 1206 she had the captive Emperor Baldwin of Constantinople assassinated by her husband in her presence because the unfortunate prisoner had refused to yield to her advances. Her cruelty and ambition, well hidden in her face by a haughty and presumptuous air, is even better borne out by the murder of her husband in 1207, in a palace revolution headed by his young nephew Boril, who followed him on the throne. Public opinion accused the not too faithful Desislava of having prompted the assassination and this was soon proved true when she married the new ruler. In 1218 Boril was overthrown and captured by the legal heir, John Asen II, who had Boril's eyes put out. We do not know whether Desislava shared his tragedy and disgrace or whether she managed to maintain her position. Tradition has it that she was confined to a convent and died a nun. In any case the force of her personality proved to have been stronger than her ill-repute, so that she was herself re-

presented on the walls of Boiana hardly a generation after her tumultuous life.

Though very much in the Byzantine tradition, the realism and fresh colours of the Boiana frescos show the vitality of the provincial Balkan societies in comparison with the static and hierarchic structure of the Imperial capital and the somewhat crystallized abstraction of late Byzantine art; no longer restricted to a strictly defined, decorative chromatism, the colours at Boiana try to render the actual colouring of their subjects. We can be sure, therefore, that Desislava's greatest charms lay in the rosy translucence of her skin and her velvet brown eyes, that we see here.

W. H. Rüdt von Collenberg

istic of certain postures in Gothic art. Her garment, adorned with heraldic lions, is also clearly Western – according to strict Byzantine rules she should have worn a robe.

W.H.R.C.

Bibliography

A. Grabar
La Peinture Religieuse de Bulgarie
Paris, 1928

H. W. Haussig
Kulturgeschischte von Byzanz
Stuttgart, 1959

Cambridge Mediaeval History, Vol. IV,
Cambridge, 1936

Krsto Miyater
Bulgaria
New York Graphic Society, Greenwich,
Connecticut, 1961

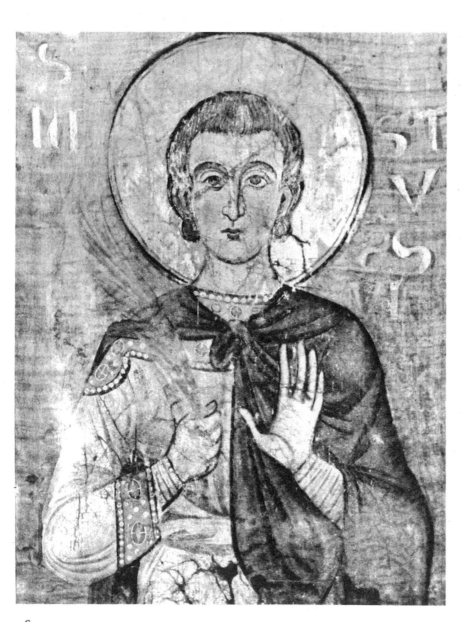

Fig. 9a. *St. Just, S. Giusto Cathedral, Trieste, 11th century* AD.

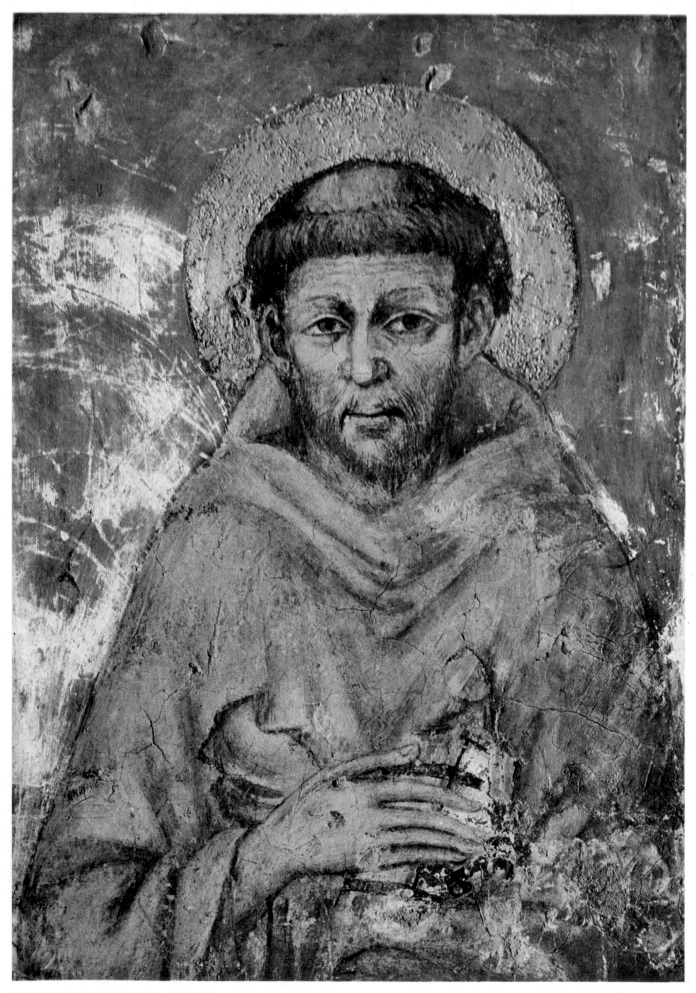

10. ST. FRANCIS OF ASSISI
Basilica of St. Francis, Assisi, Italy

Cimabue. 1272 - 1303.
Fresco painting (detail).

St. Francis of Assisi 10

**Detail from a fresco painting by Cimabue
in the Basilica of St. Francis, Assisi, Italy. 1272–1303**

Giovanni Cimabue was born in Florence about the year 1240. He was trained in the prevailing Byzantine traditions, actually working at the start of his career under Greek painters who had been brought to Florence. Though he never completely abandoned the medieval formulas, he brought a freshness and realism to Italian painting that was entirely new; the precursor of Renaissance painting (as Vasari says: 'Cimabue was, as it were, the first cause of the renovation of painting') his greatest achievement, and ironically one that obscured the originality of his own work, was that he was the master of Giotto, the great painter of the early Renaissance. According to Vasari, one of Cimabue's earliest pictures was a portrait of St. Francis (he is recorded as having painted several in the course of his life) 'portrayed ... life-like – which was something new in these times – as best he knew'. Cimabue died at the beginning of the fourteenth century.

Fig. 10a. *Madonna, Angels and St. Francis (detail), Cimabue, Italy. 1272–1303* AD.

THIS PICTURE of St. Francis painted by one of the great masters of the thirteenth century in Tuscany, Italy, is of an intense realism rare during this period. The story of St. Francis of Assisi, so important in the evolution of the Christian sentiments of poverty and compassion, was a favourite subject with the painters of the thirteenth and fourteenth centuries. Before Cimabue's picture, the face of the saint was rendered as a very stylized image as in the painting by Berlinghieri (Fig. 10b). Although Cimabue's painting is not a 'portrait' of the saint (who had died more than a half century before), the master has created a likeness so extraordinary, so attuned to what we know, that the painting remains for many *the* portrait of the 'little poor' Saint. The face that looks out at us is anything but the conventional image of a medieval saint, ugly rather than beautiful with its large ears and nose, its deeply furrowed cheeks, its shaggy beard. But in the glance that seems to be questioning us, a rare intensity is concentrated. These eyes that have clearly known physical suffering and great spiritual anxiety – the 'sickness unto death' – are nevertheless not at all sad nor absorbed by an inner vision; rather do they reflect a kind of loving curiosity about the world, a wonderful ability to listen calmly, to understand another man's soul, a fellow creature's ferocity or tenderness. In this rendering of St. Francis, Cimabue has deviated astonishingly from the traditional iconography of saints. Instead of the conventional representation of a saint as a man or woman transfigured, belonging to another world, Cimabue conveys in these features that are not noble but humble, not healthy but emaciated, something of that shock that marks for us the confrontation with that enigmatic human quality that is vaguely alluded to by the term saintly.

St. Francis was born in Assisi in 1181 or 1182 into the family of a rich merchant. The story of his life is almost legendary; taking to a life of poverty he revitalized the Christian spirit, sadly in need of renewal at the time; his love of nature, the gentle universe he created around him and which still lives after him brought the words of Christ again to the world. Summing up a very ancient tradition, Pope Pius XI has said of him: 'Men have rightly hailed St. Francis as another Christ'.

His love and charity embraced all things and his hymn to the sun is the most revealing document of all. It was composed in the little garden of the convent of San Damiano during an illness in the summer of 1225, one year before his death. St. Francis was particularly attached to this place, where his life had taken its decisive turn. In 1206 the crucifix of the ruined church of San Damiano, where Francis happened to be praying, had bid him 'Repair my church', which he did when he was converted from a life of idleness and luxury and became the apostle of joy and love ('Let the Friars beware of being sad and gloomy, like hypocrites; but let them show themselves joyful in the Lord, gay and pleasant'). He entered the service of Christ through his service to lepers, to the destitute and the humble.

Praise to Thee, my Lord, for all Thy creatures,
Above all Brother Sun
Who brings us the day and lends us his light;

Lovely is he, radiant with great splendour
And speaks to us of Thee
O Most High;

Praise to Thee, my Lord, for Sister Moon and the Stars
Which Thou has set in the heavens,
Clear, precious and fair.

Praise to Thee, my Lord, for Brother Wind,
For Air and Cloud and all Weather
By which Thou supportest life in all Thy creatures.

Praise to Thee, my Lord, for Sister Water
Who is so useful and humble,
Precious and pure.

Praise to Thee, my Lord, for Brother Fire
By whom Thou lightest the night;
He is lovely and pleasant, and mighty and strong.

Praise to Thee, my Lord, for our Sister Mother Earth,
Who sustains and directs us,
And brings forth varied fruits, and coloured flowers and plants.

Praise to Thee, my Lord, for our Sister Bodily Death
From whom no man living may escape: . . .

Cimabue's portrait of St. Francis is the perfect expression of the man who wrote these stanzas.

Anil de Silva

Bibliography

Father Cuthbert
The Life of St. Francis
Longmans, London, 1960

The Little Flowers of Saint Francis
(trans: Leo Sherley-Price)
Penguin Books, Harmondsworth,
Middlesex, 1959
Alfred Nicolson
N. A. Nicholson
Cimabue
Princeton University Press, Princeton,
1932

Eugenio Battisti
Cimabue
Istituto Editoriale Italiano, Milan, 1963

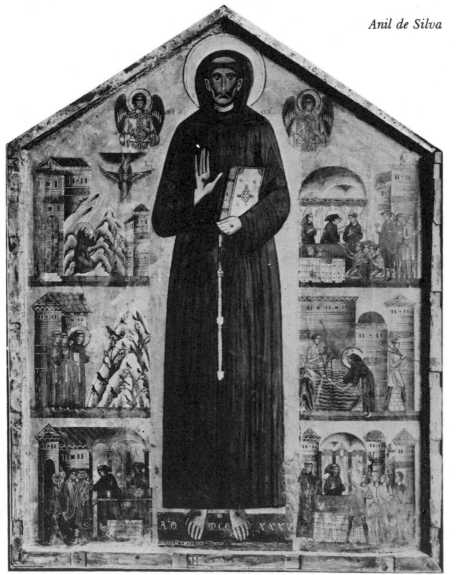

Fig. 10b. *St. Francis, from the 'Life of St. Francis' in the Church of San Francesco, Pescia. Bonaventura Berlinghieri, Italy. 1235* AD.

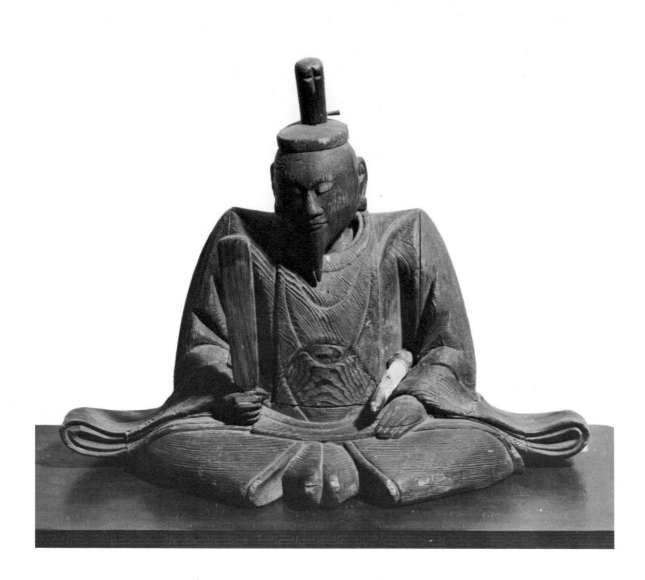

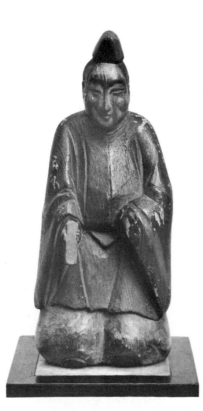

11. THREE PORTRAIT STATUES
Musée Historique des Textiles, Lyon

a) Sugawara Michizane. 9.5 in. : 24.5 cm.
 Ashikayd period 1335-1573.
b) Motoori Morinaga. 9.4 in. : 24 cm.
c) A Samurai. 16 in. : 41 cm.

Japan. 14th - 19th century.
Wooden, plain and painted.

Three Portrait Statues 11

Wooden sculptures, plain and painted, Japan. Fourteenth-nineteenth century

The series of portrait-figures barely begins before the thirteenth century. Foreign influences are less apparent in these portrait-figures than anywhere else in the Japanese art of the period. The first portrait seen here is from the Ashikaga epoch (1335–1573), when statuary was one of the arts characterized by its realism and lay inspiration. At that time the Japanese artist, having overcome the influences of foreign schools, established his own aesthetic – a true asceticism. Until this period, statues were painted in bright colours. To eliminate or to play down the painted surface is to lift the work of art to the pure realm of the spirit. It is the work of artists, highly-developed intellectually, who renounce decoration in order to concern themselves with the ideal form alone.

Motoori Morinaga (in the second portrait shown here) made a special study of Japanese antiquities, and published, in particular, a commentary in 44 volumes, a collection of ancient national chronicles. An apostle of the reaction against the philosophical ideas of the Chinese, Morinaga made a great contribution to the renaissance of Shintoism. One might see, perhaps, an allusion to his works on the Japanese origins in the ancient costume he is wearing, and also in the tablet he bears in his right hand.

The third portrait is that of a Samurai of high rank dressed in his ceremonial robes, the *kami-shimo*. The figure is made of joined wood, covered by a thick layer of paint, the carefully polished surface of which exactly imitates the appearance of flesh and the texture of cloth. Most remarkable in this piece is the vivid impression of life it conveys: we feel that we have before us the most life-like of portraits. This feeling of life should be sufficient to dissuade us from speaking, despite the polished finish of the surfaces, of its epidermal realism. Furthermore, the body has so much natural poise; the craftsman has conveyed the volumes so well that one can really see the forms under the ample garments. This is not a skilfully attired dummy, it is a fine piece of sculpture.

C.A.H.

Bibliography

Charles Arsène-Henry
Statuettes-Portraits Japonaises
Musée de Textile, Lyon, 1954

DESPITE THE FACT that, taken together, they constitute one of the most remarkable realizations of the inspiration of the Japanese artist, these portrait-figures are often over-looked in any appraisal of Japanese art. This is perhaps due to the rarity of these realistic pieces, for there are only some ten of them in existence.

The first piece illustrated here is hieratic and calm. It is no longer a decorative knick-knack, but a devotional image which formerly stood upon the altar of a legendary hero, Sugawara Michizane (845–903 AD). He was a person of great importance: while advisor to the Emperor Uda, he helped to restore the prestige of the Court crushed by the Fujiwara clan. In the reign of Emperor Daigo, Uda's son, whose accession to the throne he had facilitated, he was disgraced and exiled to the province of Tzukushi where, in the words of a historian, 'his great consolation was to climb Mount Tempai-zan and there, looking towards Kyoto, to venerate the master who had disowned him.' Justice was done to him after he died; he received posthumous preferments and was worshipped under the name of Tenjin, which literally means Celestial Spirit. It is this wisdom, this fidelity, this sacrifice, that the sculptor has been able to exemplify in the features of his hero. He has, moreover, in the general attitude of Michizane, emphasized his stiff and formal bearing, as was customary when portraying important people. The figure, in plain wood, has never been painted. The whole statuette is informed by an infinite peacefulness; in spite of its highly stylized type, it is treated almost like a portrait, and gives the impression that its maker was a master of his medium.

During the Tokugawa period (1603–1868 AD) the deep-seated tendency towards realism asserted itself, and works of art assumed an increasingly national character. Physical likeness and mental expression were, at that time, eagerly sought after. The private person was as much a subject for study as the legendary figure or man of renown. In plain wood, covered by a coat of paint thin enough to allow the grain to be visible, the second figure depicts Motoori Morinaga (see note) who lived from 1730–1801 and was a celebrated man of letters. He is depicted as a young man, which would date the statuette at about 1760. It is certainly no masterpiece, but nevertheless, the work has certain qualities. Of these the most important, perhaps, is the stark manner in which the volumes are expressed.

One can detect among the sculptors of portrait-figures, and especially in these three examples, a penchant for realism which, in spite of their taste for stylization, ultimately always triumphs. It makes us aware of a very fine feeling for volumes and a constant concern for general harmony. All these artists lacked in order to form one of the great statuary schools of the world was the opportunity to rid themselves of the conventional patterns and to say freely what they felt within themselves.

Charles Arsène-Henry

11A Self-portrait of the Artist as an Old Man

Brush-drawing by Hokusai, Japan. 1760–1849

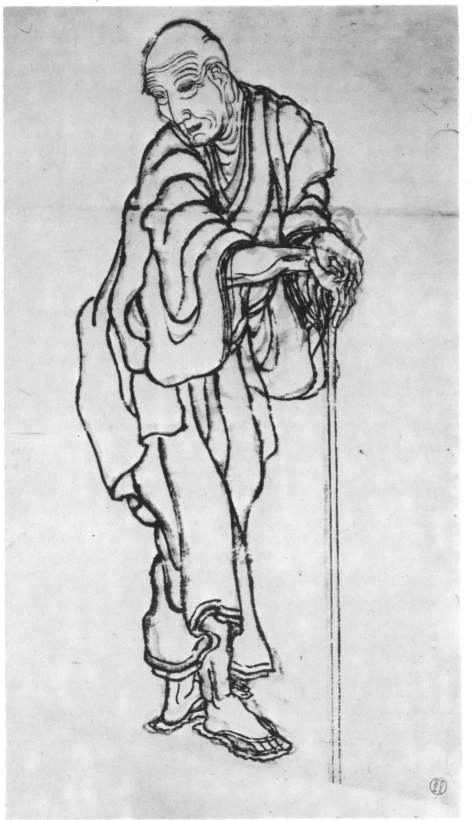

Hokusai was born in Edo (modern Tokyo) and died there at the age of eighty-nine. From 1774–1777 he was apprenticed to a wood-engraver and then, later, he studied under Sunsho, a leading artist of the *Ukiyoe* school*, who had begun designing colour-prints while Harunobu* was still alive. By the turn of the century Hokusai himself had become one of the leading *Ukiyoe* artists. In keeping with Japanese conventions, he used several different names in signing his work, including the art-name *Gwakyojin*, 'the man mad about drawing'. Though he was famous in his lifetime and gave new life to the *Ukiyoe* school, outside his own immediate circle he had scarcely any influence on his contemporaries or successors; the *Ukiyoe* tradition itself scarcely survived him by more than a few decades. The epitaph on his tomb reads *renowned original sincere man*.

*****For notes** on Harunobu and *Ukiyoe* colour-prints, see *Man through his Art,* Vol. 5, *Love and Marriage*, Plate 17.

Plate 11A. *Self-portrait of the Artist as an Old Man. Hokusai, Edo period, Japan. 19th century.*

Fig. 11a. *Various Studies, including a self-portrait (detail), Hokusai, Edo period, Japan. 19th century.*

Bibliography

J. Hillier
Hokusai
Phaidon Press, London, 1955

ONE OF THE last and greatest masters of the Japanese *Ukiyoe* school, Hokusai dedicated his rebellious and tempestuous life entirely to his art. An original genius and an innovator of great individuality, he extended the traditions of the *Ukiyoe* beyond recognition. Prolific and varied, it is especially in his drawings that we see not only an absorbing interest in the swarming humanity of the city around him (as any page from the *Hokusai Mangwa* – the prodigious fifteen-volume compilation of his drawings – would show), but also the restless energy of his own spirit; in Hokusai's work, perhaps more so than with any other Japanese artist, there comes to mind the Japanese saying 'the line is the man himself'. The fierce realism of his work was often unacceptable to those who admire the delicacy and elegance of Japanese art, who found his work often 'vulgar' and 'harsh' – 'a coarse greed for all experience', observed a critic earlier in this century, a perceptive remark which condemns its author rather than the subject of his critical insight. It is this energy and this profound sense of experience that comes through to us in this portrait of himself as an old man, with his age-worn face and the restless drapery of his robes, determinedly hobbling along on a stick, pre-occupied, self-contained, humbled perhaps by his extreme old-age and yet quite undaunted. There is probably no more appropriate commentary on this picture than Hillier's 'Epilogue': 'he died "brush in hand", arguing sorrowfully that given ten, no, given even five years longer, he might have become a great painter. His poverty and the squalor of the hovel he lived in with his daughter Oyei, his indifference to money and the eccentricity of his behaviour towards other people, were all faithfully recorded in the *Katsushika Hokusai den* from the testimony of those who had known him in his last years. It is a picture of an old man pathetically alone with his art, who had dedicated all his days to drawing and found no time for the graces of living, remaining to the end unsociable and difficult to approach, who neither drank wine nor smoked tobacco, and who only ate enough to keep his hardy old body alive. His one driving force was the urge to draw, not, certainly, to earn an easy way of life, nor even to win renown, though he was not averse to recognition; but from an innate propensity to translate everything within his experience ... into the language of the brush'.

Sēnake Bandaranayake

Fig. 11b. *Peasant and Noble, Hokusai, Edo period, Japan. 19th century.*

12 An Oni of Ife

Bronze sculpture, Ife, Nigeria. Thirteenth-fourteenth century

THE ART of Africa is most familiar to us in a great variety of powerful and dramatic masks. The complex geometry of this sculpture, sometimes terrifying, sometimes moving us with a rare, tense beauty (Fig. 12a), has penetrated to areas of experience which few other civilizations have had the language or the vision to express. It is essentially an art of ritual, an art which has evolved in a context of magic, myth and poetry: the art of Ife, on the other hand, surprising us as it does when seen against the extreme stylization of the most familiar African traditions, suggests an intellectual self-awareness, an interest in human character and personality, which in other civilizations we usually associate with a complex development of humanist thought and a philosophy of art developed over a long period of time. We have no real explanation for the extraordinary naturalism of the Ife heads, knowing little or nothing of the social history of the Yoruba people at that time. It is possible, as William Fagg has suggested, that Yoruba religion, between the eleventh and thirteenth centuries, required a life-like portraiture, just as the religious practices of the Yoruba in Owo, a town not far from Ife, require to this day! We know that the Yoruba, like all other West African peoples, were not indigenous to this region, but migrated from the North-East; it is possible, then, that the Yoruba may have retained 'some germ of naturalistic techniques gained from the Graeco-Nubian cultures of the Upper Nile' and that, in response to one kind of demand or another, they developed these forms in their new environment. And again, it may be that the Yoruba kingdoms of the eleventh–thirteenth centuries had developed an intellectual atmosphere which had, in its own way, made a naturalistic portraiture possible; it might have been an intellectual atmosphere as different as it could be from that of Greece in the sixth and fifth centuries BC, but nevertheless it produced results that were strikingly similar. It may well be a meaningful correspondence that Yoruba society at this time was organized into several city-states, in some ways not unlike those of the Greeks.

Whatever the truth of the matter may be, the art of historical Africa, of which the Ife heads are one of the most significant achievements, together with the myths and legends, the discoveries of the archaeologists and anthropologists, and the accounts of early European travellers, help us to 'envisage, at least in part, a standard of culture achieved by an orderly, peace-loving people, keenly sensitive to beauty in their environment, habiliments and art'. We know, now, that there were several civilizations in West and Central Africa, such as ancient Ghana and Melle in the north, Ife and Benin nearer the coast, and Lunda in the Congo, most of which have now almost entirely disappeared from the historical record – civilizations with 'large, populous cities, complex social systems, a general prosperity, extensive areas of land under cultivation and a highly-developed art'. In the portrait head of a Divine King of Ife we have an impressive fragment from one of these civilizations at its climax.

The fresh naturalism and intensely human dignity of the Ife bronzes and terracottas, their sensitivity to the feeling and experience that lie in the shapes and surfaces of a face certainly equal the achievements

The technical fluency of Ife naturalism may surprise us, but it seems strange in the context of other African sculpture only because of our lack of information about the history of African art. An ancient tradition of terracotta sculpture was revealed in the discovery in Northern Nigeria of the Nok heads, thought to date from the centuries just preceding the Christian era. These Nok heads anticipate the naturalism of Ife. The predecessors of Ife may well have been a collateral tradition with the Nok culture, which together with other vanished civilizations (such as those now being revealed in the Sahara) may have had one or more parent cultures, themselves perhaps connected, at some stage of their development, with the Egyptian or the Graeco-Nubian cultures of the Nile Valley. It seems likely that the West Africans, in the course of their migrations, brought with them some knowledge of working in metal by the *cire-perdue* method used by the Egyptians and the Nubians. The ambitious life-size statuary of Ife and the great bronze panels at Benin far exceed in size anything attempted in this medium by the ancient civilizations of the Nile Valley.

Fig. 12a. *Dance Mask, Gabon. Probably 19th century.*

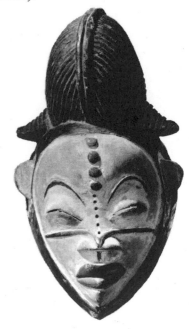

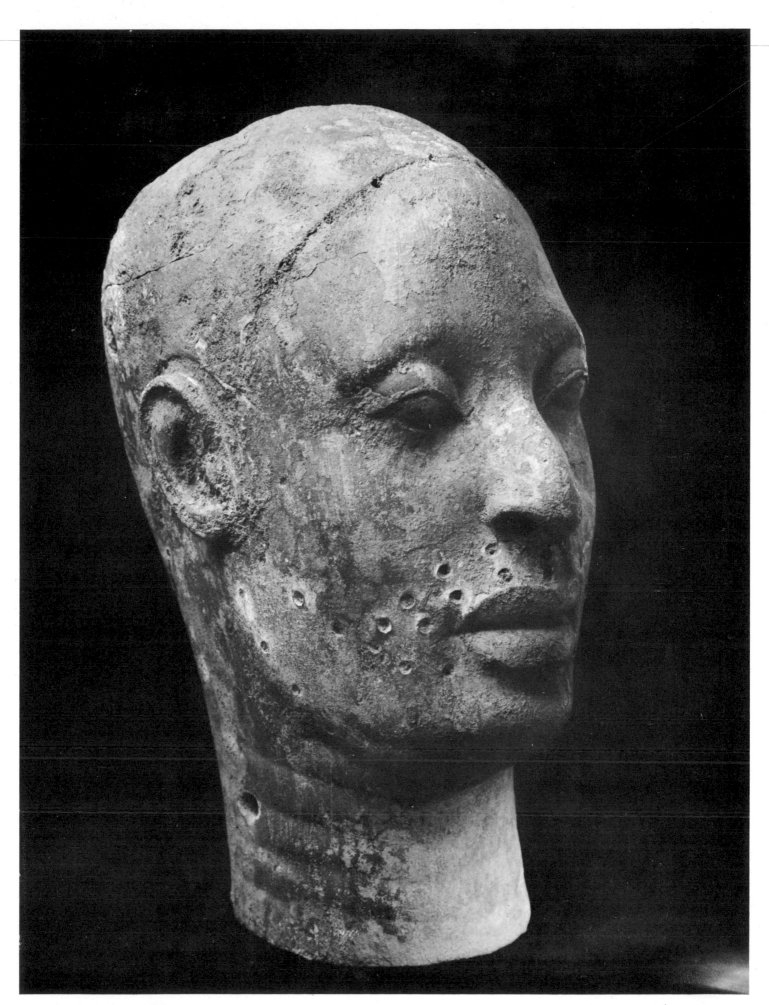

12. AN ONI OF IFE
British Museum, London

Ife, Nigeria. 13th - 14th century.
Bronze sculpture. 14¾ in. : 37.5 cm.

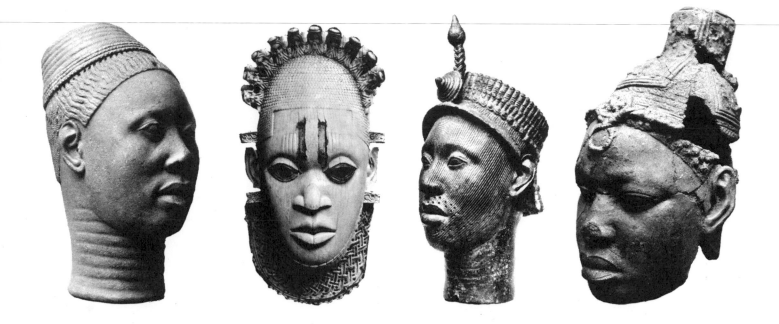

Fig. 12b. *The Lajuwa Head (an Oni of Ife, probably an usurper), Nigeria, 13th–14th century.*

Fig. 12c. *Ivory Pectoral Mask, Benin, ca. 16th century.*

Fig. 12d. *An Oni of Ife, Nigeria, 13th–14th century.*

Fig. 12e. *Ife Head, Nigeria, 13th–14th century.*

Bibliography

(Ed.) Paul Radin, James Johnson Sweeney
African Folktales and Sculpture
Bollingen Series, New York, 1952

William Fagg and Eliot Elisofon
The Sculpture of Africa
Thames and Hudson, London, 1958

William Fagg
Nigerian Images
Lund Humphries, London, 1963

of portrait sculpture in Europe or Asia. The sculpture illustrated here is a portrait head of a prince or a king, probably a memorial portrait of one of the early *Onis*, the Divine Kings of Ife, the capital of one of the important clans of the Yoruba peoples of West Africa, in present-day Nigeria. The Ife heads were first made known to the world at large in the course of excavations during the early years of this century. Since then, not only portrait heads but also busts and a full-length, life-size figure have been discovered. Though there is no certain evidence to date the Ife heads and though they show no perceptible chronological sequence, they are thought to have been the product of some centuries of development which have their culmination in the early part of the present millenium, perhaps between the eleventh and fourteenth centuries.

Tradition has it that the Ife technique of bronze-casting, by the ancient *cire-perdue* process, was transmitted to Benin around the year 1280 AD. The art of Great Benin*, one of the best documented art traditions of West Africa, certainly displays a development in time and shows, in its earliest phase in the fourteenth or fifteenth century, a close association with the distinctive naturalism of the Ife style (Fig. 12c). The present portrait and the other Ife heads shown are remarkable expressions of a personalized royalty, which impress us not by their sense of power or grandeur, but by the way in which regal dignity is gathered out of a very real sense of human personality.

Sēnake Bandaranayake

**See Man Through His Art. Vol. 3 Man and Animal, Plate 15A.*

13 Self-portrait of the Artist as St. Thaddeus

Detail from 'The Virgin in Glory', Altar-painting by Taddeo di Bartolo
Montepulciano, Italy, 1401

THE SELF-PORTRAIT as a subject was new in Italy in the last quarter of the fifteenth century, though of course there were a number of them amongst the many figures which appeared on Florentine canvasses decades earlier. Some time ago a number of these were believed to be self-portraits, but only a few stood up to critical examination. The hope of recognizing the great painters themselves amongst their contemporaries depicted in their works understandably led to mistaken identifications. It is characteristic of the changed social position of the artist that portraits of patrons were frequently presumed to be self-portraits. Some self-portraits of artists can be found in paintings dating back farther than the fifteenth century, but they were part of a composition, and not self-portraits in the meaning of the term as we understand it today. They would not be recognizable if something external did not aid identification. Even when they look like portraits, they lack the typical properties of self-portraits. This is not the case with Taddeo di Bartolo's self-portrait; though part of a late medieval altar-painting, it is a self-portrait in all its salient qualities.

Taddeo di Bartolo painted the main altar of the cathedral in Montepulciano in 1401, before he was forty. The central painting depicts the Death of the Virgin. One of the Disciples stands out from the frightened and astonished group surrounding the empty coffin. He appears to be unconcerned with the holy event. His composure sets him apart from the confusion of heads and gestures. The inscription on his halo describes him as St. Thaddeus. The individuality of his face contrasts with those of the other apostles who are typical saints in the tradition of medieval craftsmanship. He is giving a blessing in the Greek manner, a gesture full of meaning, which contrasts with the simple gestures of speech, astonishment and piety, that characterize the other figures in the picture. The manner of painting also singles him out. The surface in all its detail grows out of carefully worked layers of hatchings (see note), in which white is added to the colours, a technique which reappears, with modifications, in portrait painting at later dates. The heads of the other saints are more roughly worked and in the traditional technique of fewer layers with fixed hatchings, some serving a plastic, others a colouristic purpose. Their final form is already fixed in the underpainting. One might imagine that the artist is honouring his patron saint in a special way, but posture and expression prove that Taddeo di Bartolo depicted himself as St. Thaddeus. The limited turning of the head towards the profile, barely permitting a glance into a mirror, which turns the eye into the picture plane while projecting the glance away from it – all these are peculiarities of many self-portraits. A double result obviously arises when a painter confronts himself. On the one hand, intensive and concentrated attention, sharpened to grasp every detail, produces a wide-eyed, critical and searching look; on the other hand, reflective self-knowledge makes visible the heightened seriousness of expression in the process of creation. This gives rise to that immediacy and tension to which most self-portraits owe the look of deep contemplation, and to the expression of a searching attention and an almost complete absorption into the act of vision. That this concentration can be heightened to visionary

Fig. 13a. *The Virgin in Glory, by Taddeo di Bartolo. Main Altar-piece from the Cathedral at Montepulciano, Italy. 15th century.*

Taddeo di Bartolo was born in Siena around 1363 and died around 1436. Working mainly in fresco, Taddeo was the last of the great painters of the Siennese school, which flourished between the thirteenth and fifteenth

Fig. 13b. *Detail from The Virgin in Glory.*

**13. SELF-PORTRAIT OF THE ARTIST
AS ST. THADDEUS**
Cathedral at Montepulciano, Italy

Taddeo di Bartolo. 1401.
Altar-painting (detail).

Fig. 13c. *St. Pape, by Master Theodorik, Czechoslovakia, 1357–1367.*

centuries, and which is especially known by the distinctive work of its great master, Simone Martini (*ca.* 1283–1344). The influence of Simone Martini is clearly present in the work of Taddeo di Bartolo.

The fact that the early attempts at self-portraiture lack the typical properties of self-portraits becomes obvious, for example, in the self-portrait of Agnolo Gaddi in his fresco 'The Entry of Heraclius into Jerusalem' (Florence, S. Croce, *ca.* 1380). It is a portrait in profile and must have been painted with the help of two mirrors, a technique already mentioned by the Roman writer, Pliny. It reproduces an aspect which allows it to be recognized as a portrait, but not really as a self-portrait. Proof was adduced only through its being used again in the family portrait which bears the names of the three brothers Taddeo, Gaddo and Agnolo Gaddi (Uffizi).

Hatchings are incised or engraved lines used in tempera and fresco paintings and in engravings in order to convey depth or variations of tone. In tempera and fresco, the hatchings are formed by the brushwork, while in engravings they are cut in parallel or crossed lines by an engraver's tool.

levels is ancient lore, as shown by the use of mirrors in magic.

The face of St. Thaddeus shows all these peculiarities of self-portraits to the fullest extent permitted by the conventions of this early period. The mould which stood for 'man' around 1400 is filled to overflowing with lines which are alive and personal, with a distinct individuality of expression.

Compared with the well-known examples of self-portraits from the second half of the century, Taddeo di Bartolo's self-portrait is not simply old-fashioned or restricted; it is not just a precursor, an early beginning of the subsequent proud development; undoubtedly, it is based on different assumptions. The Italian self-portraits of the late fifteenth century show a self-confident desire to stand out in the company of portrayed contemporaries, a joy in the assertion of one's self. In Taddeo di Bartolo's face, on the other hand, we see, questioning and uncertain, the look of late medieval religiosity, with its sense of inquiry and anxiety. The later painters portrayed themselves presenting a gift or as observers and authors. Taddeo, on the other hand, depicts himself in the person of his patron saint, his solitary portrait hidden in the representation of a sacred event. Thus his self-portrait attests a heightened devotion, which seeks a secret and intimate connection with the events of salvation, fusion of the personal and the holy. There is a great deal of evidence for this longing at that period. The mystic piety of Siena must be recalled as the background to this early self-portrait. It asks the questions which moved men at the wane of the Middle Ages. Thus the first genuine self-portrait in the history of European art came into being – more than a generation before the beginning of the development of self-portraiture proper – as part of an altar-piece that in form and subject matter is still confined within the medieval outlook.

What lifts it out of this context is the life it breathes, a life peculiar to itself. Beyond this, the face is an impressive statement about western man.

Christian Wolters

14 The Blind Face

Detail from 'The Parable of the Blind', an oil painting by Brueghel the Elder Flanders (now Belgium), 1568

BRUEGHEL HERE illustrates the words from the Gospel of St. Matthew, XV, 14, 'If the blind lead the blind, both shall fall into the mire'. He was not the first artist to be attracted by the parable, but he has rendered it as no artist before or since. Whereas among the artists who inspired Brueghel, Bosch showed two blind men and Massys four, their number is raised to six by Brueghel, which only protracts our tension and fearful expectation of the fall we know to be inevitable for all of them. The crescendo in the expression of the faces, reaching an almost unbearable climax in the man who has lost his balance and is about to fall, is matched by the expressiveness of the postures, by the gradual increase in unsteadiness. Although they are greatly differentiated, each man fully and unforgettably represents as it were the idea of blindness itself.

The great artist is a creator of types. His images become our images, and if we see old age with the eyes of Rembrandt (Plate 16), we owe our image of blindness to Brueghel. In the Naples picture Brueghel has given final expression to what occupied him for many years. In 1559 he had included blind men in his picture *Carnival and Lent* and in 1562 he made a drawing of three blind people (Fig. 14b), and from several early inventory entries as well as from paintings by other artists which appear to be inspired by Brueghel, we can deduce the existence of further compositions of this kind. If there is pity and compassion for the physical affliction in the earlier works, its symbolic content endows the later painting with a new sense of tragedy and grandeur. The inner

For a note on Peter Brueghel the Elder, see *Man through his Art*, Vol. 4, *Education*, Plate 14.

Fig. 14a. *The Parable of the Blind (whole picture). Oil painting by Brueghel, Flanders (now Belgium). 1568.*

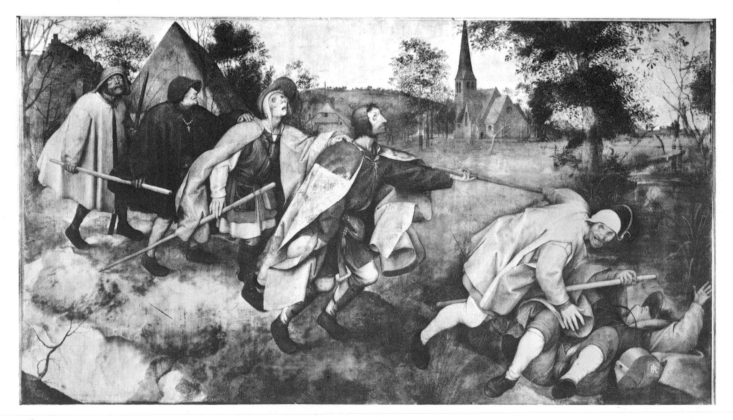

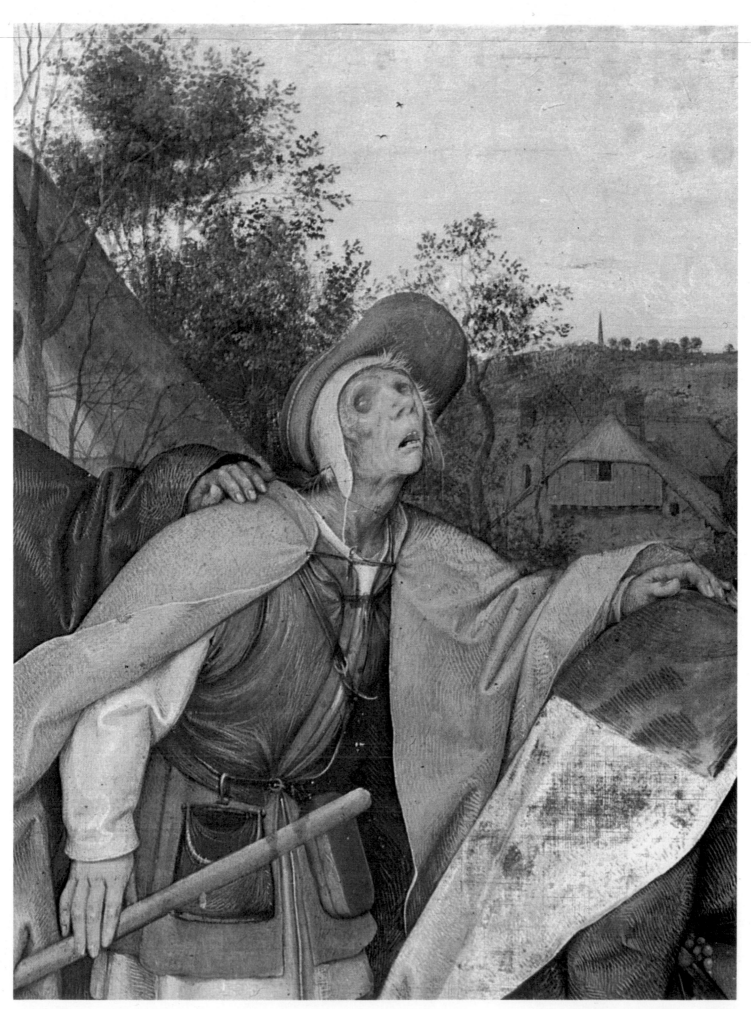

14. THE BLIND FACE
Museo Nazionale, Naples

Peter Brueghel the Elder. 1568.
Oil painting. 33⅞ × 60⅝ in. : 154 × 86 cm.

Fig. 14b. *The Blind Men. Drawing by Brueghel.*
1562.

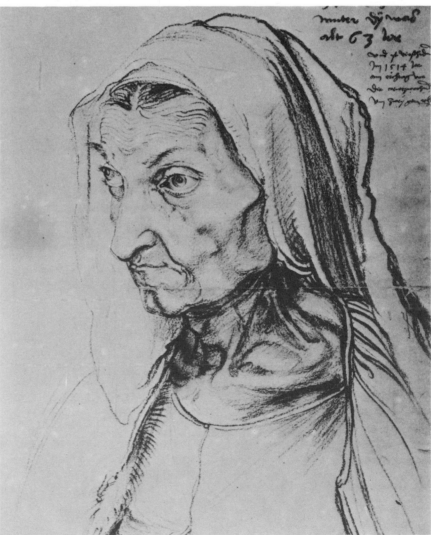

Fig. 14c. *Portrait of the Artist's Mother.*
Albrecht Dürer, Germany. 1514.

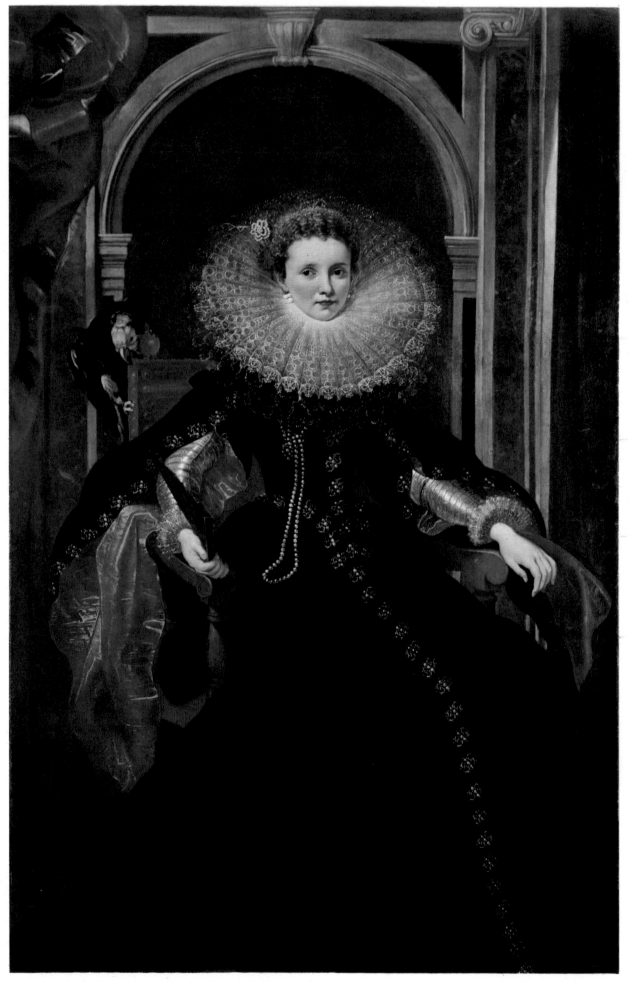

15. MARCHESA VERONICA SPINOLA
Staatliche Kunsthalle, Karlsruhe

Rubens. 1607-1608.
Oil painting. 84.6 × 54.5 in. : 225 × 138.5 cm.

Marchesa Veronica Spinola 15

Oil painting by Rubens, Flanders (now Belgium), c. 1607–1608

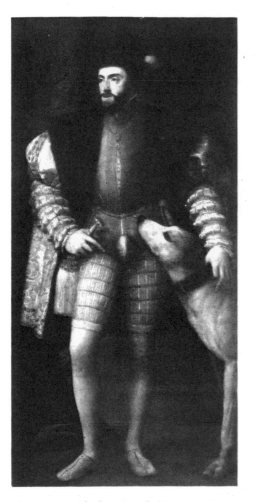

Fig. 15a. *Charles V with his Dog. Titian, Venice, 1533.*

By the sixteenth century the life-size full-length 'state-portrait' had become the privilege of kings and members of reigning families. This type of portrait, which had earlier been used in the representation of burghers and their families, became the conventional manner of showing princes before 1550 owing to the work of Jakob Seisenegger, the Habsburg court painter active at the Imperial residence in Vienna. It was of special importance that the Emperor Charles V also commissioned a full-length portrait from Seisenegger. The new mode in portraiture was soon taken up by the Spanish court in Madrid, and Titian and the Dutch court painter Antonis Mor were commissioned to paint full-length portraits of Philip II and several members of his family. As early as 1533, the Emperor had asked

THIS PORTRAIT of a young Genoese lady was painted by Rubens around 1607–1608, towards the end of his stay in Italy. The subject sits erect and motionless, but though her figure is built up in the foreground, close to us, it is not really a full-face portrait. A slight turn to one side, combined with the proximity of the figure, create a sort of inner distance between the portrait and ourselves, an effect which is emphasized by the ceremonial bearing and the precious robes of the Marchesa. The high chair, with its back and two armrests, supports and frames her stiff posture, and the arcade between the pilasters in the background provides yet another severe frame for the erect figure. The colours are also subjected to the simple and severe composition. The drapery, high on the left, shows red and silver squares on gold, the heraldic colours of the Spinola family. To this triad of colours corresponds the pigmentation of the parrot, the golden yellow tones of its head, the red stripes on its wings and the whitish plumage on its feet. It is also taken up by the golden lining of the Marchesa's sleeves, the dark red upholstery of the chair and the white lace on the collar of her dress. The shy, girlish expression of the Marchesa and the parrot's nervous pecking at the back of the chair introduce a noticeable animation into the severe architectural composition which dominates the figure, the background and the colours. The light coming from above, behind the emblazoned cloth, also brings life into the solemn and majestic representation. It stresses the Marchesa's face and hands, the parrot's plumage, the wide lace collar; the golden silk lining of the sleeves glitter in it and the rich jewellery gleams on the dark foil provided by the robe. The young noblewoman appears in full figure and thus conveys a distinct claim to social eminence.

Rubens spent the summer of 1603 at the Spanish court, at that time still the centre of the strongest continental power. He was there on a diplomatic mission. Rubens was already familiar with the new kind of full-length portrait. He must have seen pictures of this type at the Brussels palace of the Governors of the Netherlands and met it again at the court in Mantua, in works by his compatriot Frans Pourbus. At the same time, he must have experienced the representative power and the emphatic assertion of dignity of the full-figure portrait with renewed intensity in Madrid. Naturally, the strongest impression on him was not made by the works of the Spanish court painters, but by Titian's paintings such as the *The Emperor Charles V with his Dog* (Fig. 15a) or *Portrait of Philip II in Armour* (Fig. 15b) after Seisenegger (both Madrid, Prado).

Another prototype created by Titian, the portrait of the sitting emperor (1548) in the Munich Pinakothek, gave Rubens the decisive impetus for his portraits of seated Genoese ladies. Around 1605–1606 Rubens produced in Genoa the portrait of the Marchesa Bianca Spinola Imperiale with her niece Maddalena Imperiale (Stuttgart). The composition of this painting shows all the essential elements of the Munich portrait of the Emperor by Titian.

The specific association of the full-length portrait with the world of great European courts, determined Rubens' Genoese portrait commissions. The rich commercial magnates of the Ligurian metropolis,

the Doria, Spinola, Imperiale, Grimaldi, or Pallavicini, possessors of Imperial patents of nobility, entitled to call themselves 'Marquis', had built themselves impressive palaces in Genoa where they surrounded themselves with the trappings of a princely court. Their aristocratic pride demanded expression in portraiture. The conventional Spanish 'state-portrait' must have appeared to them as a suitable medium to express their claim to social, political and economic importance. Thus Rubens introduced the full-length portrait which had matured at the courts of the Emperor and the Habsburg Kings – an achievement that 15 years later left its imprint upon the Genoese art of Van Dyck.

Between 1630 and 1640, van Dyck introduced the full-length portrait of aristocratic personalities in England, where its influence can still be seen in the eighteenth century portraits of Gainsborough, Lawrence and Reynolds.

In 1602 Rubens gave a brilliant opening to his series of Genoese portraits by painting Giancarlo Doria, the son of the reigning Doge, dramatically posed on horseback. Rubens thus created his first equestrian portrait. Giancarlo Doria married Veronica Spinola in June 1608. It is reasonable to suppose that the Doge's son also commissioned a portrait of his bride from Rubens, and that it is this painting that is preserved for us in the masterpiece seen in our plate. The Spinola colours, certain stylistic peculiarities which suggest the last year of Rubens' stay in Italy, the age and the somewhat shy expression of the sitter, and lastly, the fact that Giancarlo Doria's brother, Giacomo Massimiliano, had earlier commissioned Rubens to paint a portrait of his bride Brigida Spinola, make it highly probable that the Karlsruhe painting represents Veronica Spinola, who was twenty-one years old at that time. In our picture, Rubens has blended the Spinola's claim to grandeur (which implied the power and flowering of Genoa), the delicate personality of the young Marchesa and the charm of her precious robes and jewels into an artistic whole of rare conviction. The human appeal of this painting, which speaks to us most strongly, emanates from the face; it gathers the light to which the architecture of the painting draws our attention, while a shy and pensive glance is directed at us.

Justus Müller Hofstede

Fig. 15c. *Studies of a Negro Head. Oil painting by Rubens, Flanders (now Belgium). ca. 1620.*

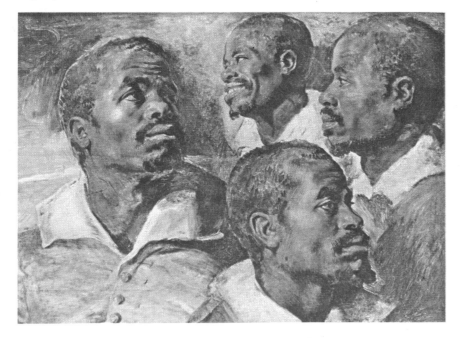

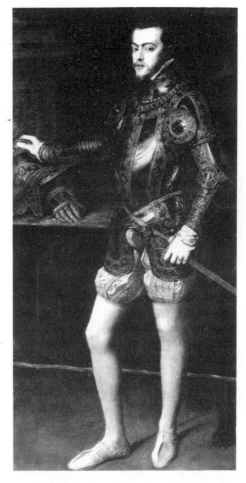

Fig. 15b. *Philip II. Titian, Venice, Italy. 1551.*

Titian to repeat his portrait painted by Seisenegger. The Spanish court painters Sanchez Coello and Pantoja de la Cruz accepted the full-length portrait as a fixed convention. Thanks to the prestige of the Spanish monarchy the type gained wide acceptance in the second half of the sixteenth century. It is characteristic of the ceremonial atmosphere surrounding Philip II that the portraits of Mor, Coello and Pantoja almost invariably show standing figures, only rarely depicting sitting figures.

J.M.H.

For a note on Peter Paul Rubens, see *Man through his Art,* Vol. 1, *War and Peace,* Plate 14.

Bibliography

L. Burchard
'Genuesische Frauenbildnisse von Rubens'
Jahrbuch der preussischen Kunstsammlungen, L, 1929

J. Müller Hofstede
'Bildnisse aus Rubens' Italienjahren'
Jahrbuch der staatl. Kunstsammlungen in Baden-Wurttemberg. II, 1965

K. Locher
Jakob Seisenegger
Hofmaler Kaiser Ferdinands I.
Munich, 1962

Self-portrait 16

Oil painting by Rembrandt, Holland, *c.* 1660

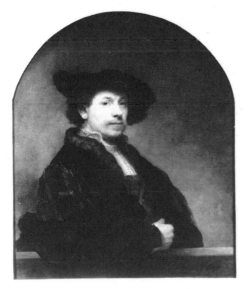

Fig. 16a. *The artist and his wife, Saskia. Rembrandt, Holland. ca. 1635.*

Fig. 16b. *Self-protrait as a Young Man. Rembrandt, Holland. 1640.*

THERE ARE PAINTERS for whom the self-portrait means a search for the deep self, an investigation of the inward man, a seeking after the invisible down the paths of the visible, and in some writers that kind of questioning takes the form of the intimate journal; it is a means of knowing oneself at the present moment, and, even more than that, it is a means of recording the modifications that have occurred in the physical and moral personality of the individual over the long course of those ever burgeoning days and years, which have now passed away. Such a study is only possible when we can assume that the individual remains one and unified, in spite of his metamorphoses.

Some painters, when painting their own portraits, seek only the exterior of their model, and show curiosity and interest only in regard to the play of forms, lights and colours, and describe their own faces just as they would describe the faces of strangers, or even a landscape, or the objects assembled to serve as models for a still-life. The material identity of the person, his singularities, which cause the perpetual surprises experienced by a man when he looks in a mirror at his own reflection, and the changes which the lighting in the room, of the time of the day, and of the season bring to that face, make it an object of inexhaustible analysis. When the artist is haunted by the sensation, rather than by the mere idea, of the flight of time, his description of the gradual collapse and weakening of the relief and outlines of the face ends in a kind of tragic contemplation of the temporary and the perishable. The hundred or so self-portraits which Rembrandt painted, engraved or drew during the course of his life constitute an attentive, meticulous recording of what happened in his flesh – what decomposed, and what was destroyed – but also inform us of the attacks and assaults which bit and tore into the very tissue of his soul. The earliest of these self-portraits date from his youth, and even from his adolescence. In this period the individual is drawn by all the appeal of the outer world; he tends to go out from himself and employ his strength in an effort at conquering the world; this ardent and generous extraversion turns him away from himself and draws him towards the other. This is why Rembrandt adopts a certain number of masks at this stage in his self-portraits, and even paints some through curiosity and caprice, in order, so it seems, to put some distance between himself and his knowledge of himself, rather than to capture the riddles in his own personality; the masks amused him, and also served to relieve him temporarily from that giddiness brought on by his perception of those depths, into which he was one day to be absorbed.

Once having bared himself to himself before a mirror, the young Rembrandt chose two ways of evasion from himself: disguise and masks. Right through to his maturity, and even down to the threshold of his old age, when all fantasy and curiosity about the external world left him, he was to take pleasure in transforming his appearance with the aid of strange headgear, exotic garments, and theatrical costumes, all of which gave him the illusion of being somebody else, another. His imagination showed him what he would really have been like if he had been that different person to whom such garments belonged and for whom they were suitable. He multiplied himself by such metamor-

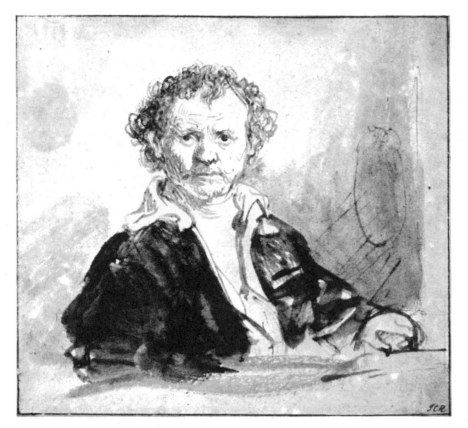

Fig. 16c. *Self-portrait. Rembrandt, Holland. ca. 1648.*

The young Rembrandt between his twentieth and his thirtieth year, remained a child, even an 'amateur' in many ways, who kept his taste for student 'ragging'; he clowned and played the fool before his mirror, and sought out comic, amusing expressions, which are at one and the same time caricatures of his usual face and an investigation of the manner in which feelings are expressed by the physiognomy. Therefore, in his drawings and engravings (rather than in his paintings, for he considered that many passing aspects do not deserve to be painted) we can observe a whole characterology of expressiveness, similar to the characterologies which were constructed by Messerschmidt and Boilly in the next century – a great period of psychological investigation. The influence of the theatre is visible here, for Rembrandt had a great love for the theatre, and he studied the disposition of light and the arrangement of the scene with as much care as he gave to the actors in his paintings. His inborn taste for auto-metamorphosis, manifest in the number of self-portraits which he executed, was stimulated and reinforced by his

phoses. He essayed possibilities of being, which seemed limitless to him. Through escaping from the enclosed self, he can imagine that multiplication of his self, which permits him to wear clothes proper to other selves.

But garments are, after all, only additions to the human being: they do not form part of it; they are things which become attached to it but do not essentially modify its substance; when they are detached, that substance is not essentially diminished or impoverished. Disguise belongs, to a large degree, to what is common to men, or at least to large groups of mankind; but the mask signifies what is unique, what a single individual may regard as his own inalienable, indivisible and unshareable possession and good.

The young Rembrandt therefore used masks, just as he used disguises in order to vary his self-portraits, but he did not choose masks properly so-called, since, to put on a mask is to alienate oneself, renounce oneself, make one's reality disappear behind appearances; he used mobile masks, temporary masks, those masks which are well known to children and which are called 'making faces' (see note).

There was a moment in the life of Rembrandt when this tendency towards exteriorization ceased abruptly, and was replaced by an increasing and constant turning inwards upon himself, which introversion may be recognized through the disappearance of the accessories in which he had once delighted and the exclusion of everything that did not belong to his deep self. The curiosity which the artist felt for that inward, hidden, secret identity was stronger and more intense than the curiosity which had made him grimace and disguise himself in his youth. From now on the only modifications of the self which he was to observe were those which betrayed the aging of the exterior being, and, within, the heavy, powerful waves of emotion which troubled his mind and his heart, and which mounted to his face, where they modelled the fleshy masses, dug deep wrinkles, and pulled out

Fig. 16d. *Self-portrait (detail). Rembrandt, Holland ca. 1656–1658.*

Fig. 16e. *Self-portrait (detail). Rembrandt, Holland. ca. 1660.*

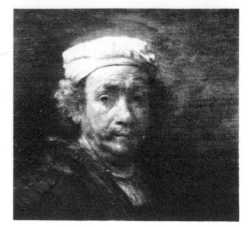

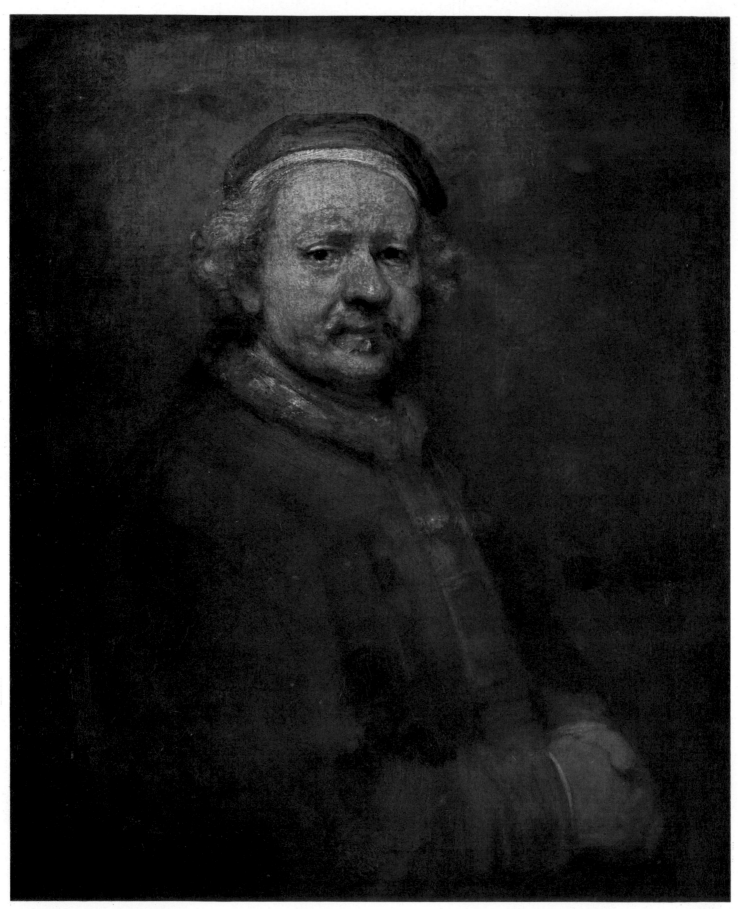

16. SELF-PORTRAIT
National Gallery, London

Rembrandt. *ca.* 1663.

Oil painting. 33⅞ × 27¾ in. : 86 × 70.5 cm.

Fig. 16f. *Self-portrait (detail). Rembrandt, Holland. ca. 1663.*

mixing with actors, who are also beings in a state of perpetual metamorphosis, and by the interest which tragic situations and representations of them stirred up in him (he illustrated a Dutch translation of Calderon).

M.B.

For a note on Rembrandt, see *Man through his Art*, Vol. 2, *Music*, Plate 14.

Bibliography

Jacob Rosenberg
Rembrandt
Harvard University Press, Cambridge, Mass., 1948

Focillon and Goldscheider
Rembrandt
Phaidon Press, London, 1960

the skin. But, unlike the portraits which go up almost to his fortieth year, his last self-portraits are wholly portraits of his soul. This does not mean that the painter subordinated technique and matter entirely to psychological analysis; on the contrary, his genius appears greater and bolder than ever before in his treatment, his brush strokes, his handling of the paint, but his look has changed direction. For him the face is now only the place where the tragic conflict occurs between the living being and that process of aging which is the approach of death.

Everything that refers to an outside world seems to have been pushed away, rejected, refused; the garments have the vague, loose lines of soft, neglected cloth. An old cap, or a scarf carelessly knotted without pleasure, covers his head. His drama is acted out without scenery, without costume, on a bare stage, across which the lengthening shapes of the approaching shadows of death are thrown from the wings. The last self-portraits of Rembrandt are not so much the last statements of a psychological analysis, as a record of the advance of a destiny imprinted in the flesh of a man. Lorenzo Lotto and La Tour were greater psychologists than Rembrandt, but he alone knew how to face, eye to eye, the miserable reality which is our common condemnation to old age and death; he was the only one who was able to make a passionate study of it, who went beyond feelings and sensations to express his conception of the tragic character of existence, without drawing upon an exterior event, but solely by describing the progressive destruction of the body.

This destruction is made sadder, and swifter, by the inward decomposition of the moral being; the sufferings accumulated in the course of the years, the departure of beloved persons who once were always present, the disappointments and the sadness of an old artist, who was neglected, misunderstood and disregarded even by his contemporaries, and a metaphysical anxiety which goes very near to despair, all these things are revealed in the faces in the last self-portraits by Rembrandt: they tell us of the silent mounting of anxiety about the day after tomorrow, that inscrutable, unforeseeable future which is waiting for man on the other side of the gates of death.

Marcel Brion

Fig. 16g. *Self-portrait (detail). Rembrandt, Holland. ca. 1666.*

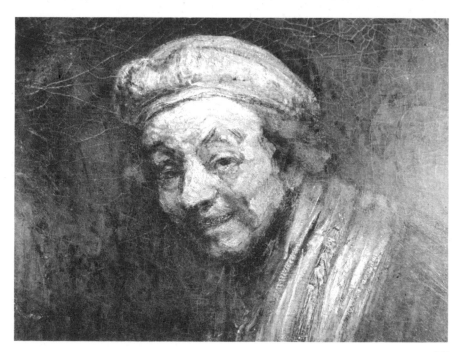

17 Charles IV

Oil painting by Francisco Goya, Spain, 1799

N O GENIUS seems more spontaneous than Goya's; his dreams, his reality, his style, even that break in the flow of the brush-work by which his workmanship can be recognized at a glance, were all his own creation. Sometimes he skimps a picture; sometimes he seeks colour combinations of the rarest quality; sometimes he uses a model, as for instance in his portrait of Isabel de Porcel; he often places it in a private world which becomes apparent when a dozen of his pictures are assembled.

Goya's reputation for cruelty rests entirely on his portraits of the royal family. The great take no delight in being made to look ugly, even for the sake of good painting, and he painted the queen at least twenty times and the king fifteen. We are amazed that the family of Charles IV should have looked on with pleasure at the freakish array that Goya depicted: but was not that same family even stranger, and did it not see in that terrible canvas a friendly mirror? 'She has her heart and her life in her face', said Napoleon of the queen, 'and that surpasses all imagination.' Goya did not try to ennoble; in this respect, he is as far from Rembrandt as the latter is from Leonardo da Vinci, but he seeks a metamorphosis no less complete. The passionate energy with which he tried to wrest the figures of his etchings from their human condition is sensed again here, less apparent, but no less effective. After his illness in 1793 his art as a portrait-painter developed into one of the richest and most subtle the West had ever known.

Fig. 17a. *Self-portrait, (detail), Goya, Spain.*

Fig. 17b. *Charles IV and the Royal Family, Goya, Spain. ca. 1800.*

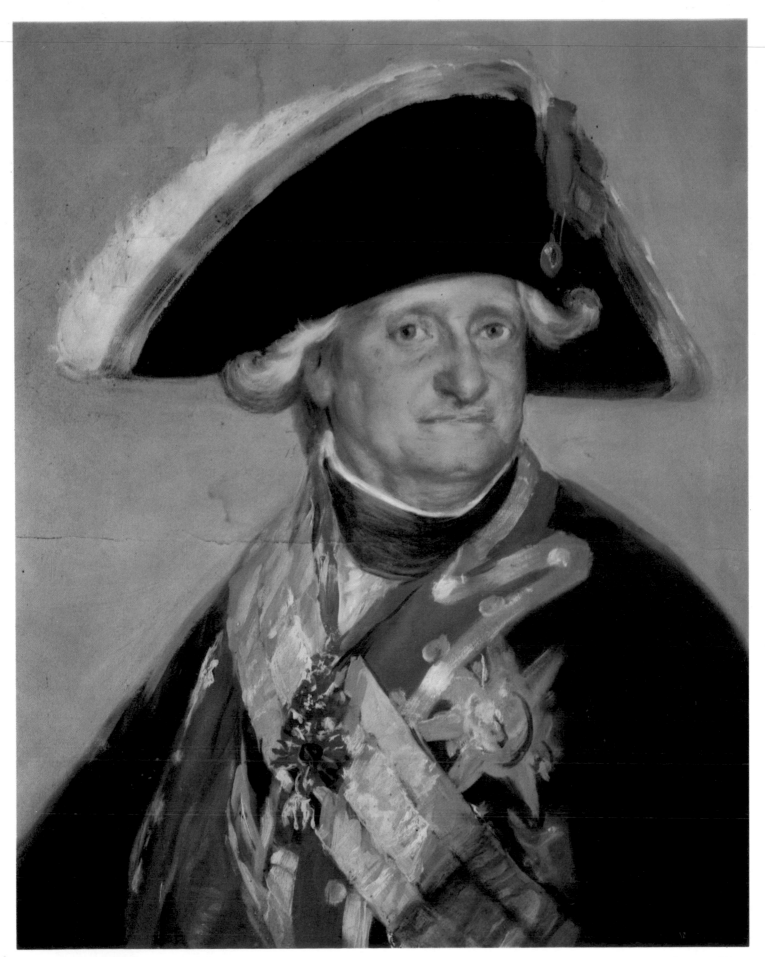

17. CHARLES IV
Prado Museum, Madrid

Goya. 1799.
Oil painting (detail).

18A Daniel Crommelin Verplanck

Oil painting by John Singleton Copley, U.S.A. 1771

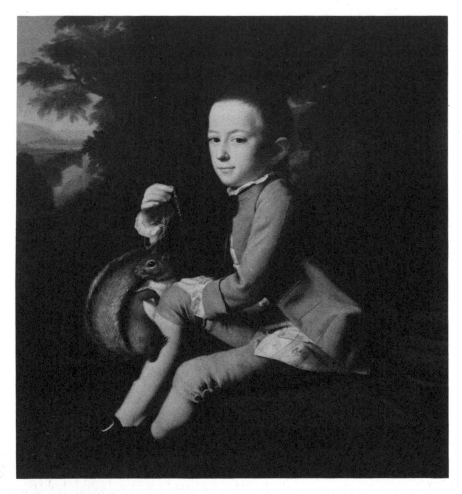

Plate 18A. *Detail from Daniel Crommelin Verplanck (1762–1834). Oil on canvas, by John Singleton Copley, U.S.A. 1737–1815.*

John Singleton Copley was born in Boston, Massachusetts, in 1737, of English and Irish parents. Having established himself as a portrait painter at home, he left for Europe in 1774 and, after a year in Italy, settled in London. There he soon established a reputation for himself as a painter of historical subjects and was elected to the Royal Academy.

For a note on American Painting see *Man through his Art*, Vol. 5. *Love and Marriage*, Plate 20.

This text has been edited with the kind permission of Mr. Denys Sutton and the Metropolitan Museum of Art, New York.

Bibliography

Albert Ten Eyck, Gardner and
Stuart P. Feld
American Painting – A Catalogue of the Collection of the Metropolitan Museum of Art, New York

Denys Sutton
American Painting
Avalon Press and Central Institute of Art and Design, London, 1948

THIS PORTRAIT of Daniel Verplanck, who was then nine years old, was painted by the American artist John Copley at the height of his powers. Denys Sutton says: 'Copley has left a remarkable series of portraits of the colonial period on the eve of the American Revolution . . . The claim is frequently advanced that realism is the proper American tradition and that the realistic portrait of the eighteenth century was a sign of the colonial reaction against the overbearing English aristocracy, a symbol of nascent American democracy. It is not always proved; the realistic portrait at this period was not confined to America alone, but was in fact the result of a general reaction against the tradition of aristocratic portraiture. This reaction was partly occasioned by the emergence of a new circle of patrons: in America, as in Europe, the wealthy middle classes had grown in power and political importance. They certainly desired a voice in the government of the country. The rich colonial mercantile classes evolved a culture of their own which found genuine expression in domestic architecture and in the interior of their houses.'

The clarity of the portraits John Copley painted in America was

Fig. 18a. *General Andrew Jackson (1767–1845). Samuel Lovett Waldo, U.S.A. 1783–1861.*

Fig. 18b. *George Washington (1732–1799).*
Rembrandt Peale, U.S.A. 1778–1860.

Fig. 18c. *George Washington (1732–1799).*
Gilbert Stuart, U.S.A. 1755–1828. (Painted
1800–1803).

Fig. 18d. *Mrs. James Montgomery (Eliza*
Kent). Thos. Sully, U.S.A. 1783–1872.

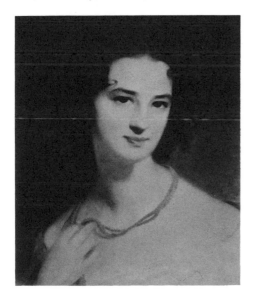

a reflection of the well-balanced, confident society in which he lived, a society which believed that the cultivation of the habits and manners of the English gentry was an essential part of education. This society, however, was to undergo a decided change in the first half of the nineteenth century and the artistic style evolved during the colonial period was gradually transformed. Copley set the seal on the specifically colonial style of portraiture.

The War of Independence had sounded not only a call to nationalistic sentiment, and brought the nation together; it had seemed to contain a promise for the future. Artists had felt that an opportunity was at hand to create that school of historical painting which was the natural ambition of any artist of the period, in America as in Europe. The close of war seemed indeed a propitious moment for the realization of such pious hopes. A year after the conclusion of hostilities the City of New York commissioned a series of full-length portraits of naval and military heroes, from artists like Thomas Sully, Samuel Waldo (Fig. 18a) and John Jarris.

Rembrandt Peale (1778–1860), himself the son of the artist Charles Peale, was eighteen when he painted a portrait of George Washington, the first President of the United States. It has a curious story attached to it, for this portrait haunted Peale all through his life. Several years later he gave a lecture on Washington's portraits where he related: 'At my father's request, Washington consented to sit for me and the hour appointed was seven o'clock in the morning. I was up before daylight, but before that hour arrived, became so agitated that I could scarcely mix my colours, and was conscious that my anxiety would overpower me. . . .' Subsequently, Peale painted a number of portraits of Washington from memory. After sixteen such attempts to fix the 'image', as he said, he determined to make a '*last effort*'. Preparatory for this, I assembled in my room every document representing in any degree the man who still *lived in* my memory . . . Whilst contemplating these with the deepest attention . . . my wife entered and anxiously asked my purpose. When I told her, she burst into a flood of tears and exclaimed with great emotion that Washington was my evil genius and she wished he had never been born. I promised her that this should be my *last* attempt. I commenced and devoted all my time to it to the neglect of every other business. . . .'

Fig. 18b is one of nearly eighty replicas that Peale made of his so-called 'port-hole' portrait, his last effort!

Gilbert Stuart's portrait of Washington (Fig. 18c) was also done from life and has been described as 'The greatest portrait of the greatest of men, fascinating and hypnotic as no other . . . Stuart has reached the climax of his art, and the noblest expression.' It forms an interesting comparison with that of Fig. 18b by Peale.

The portrait of Mrs. James Montgomery (Fig. 18d) by Thomas Sully (1783–1872), shows an example of the work of one of the foremost American portrait painters. He earned a reputation for being 'remarkably happy in his women. His female portraitures are oft-times poems full of grace and tenderness, lithe, flexible and emotional; their eyes, too, are liquid enough and clear enough to satisfy even a husband or a lover. Nobody ever painted more beautiful eyes.' Sully himself describing his method of painting portraits in his *Hints to Young Painters*, says: 'When the person calls on you for the intended portrait, observe the general manner, etc. so that you may determine the attitude you had best adopt . . . At the next sitting make a careful drawing of the person on a grey canvas . . . It should be of a middle tint . . . it must not shine . . . six sittings of two hours each is the time I require. When alone, begin the portrait from memory . . . Paint freely as if you were using water colours, not too exact, but in a sketchy manner. . . .'

Anil de Silva

57

which captured not only their personalities, but a whole way of life. Rayski, who never married, seems to have become odd and eccentric as he grew old; people smiled at his crumpled clothes and often seem to have considered inviting him to their homes a charitable obligation. None, so far as we know, realized that the perfect manners of early manhood and the oddities and silence of his old age concealed an inner life as rich, sensitive and fresh as his best work.

*See *Man through his Art*, Vol. 5, *Love and Marriage*, Plate 19.

Bibliography

M. Goerlitz
Ferdinand von Rayski und die Kunst des 19. Jahrhunderts, Berlin, 1942

M. Walter
Ferdinand von Rayski, sein Leben und sein Werk, Leipzig, 1943

The portraits of the preceding centuries have been pre-eminently concerned with man's estate; the painters of the fifteenth, sixteenth and seventeenth centuries had to concentrate on the dignity and the elegance of the sitter, on the trappings of social eminence. Rubens' young Marchesa (Plate 15) is a lovely woman, but, above everything else, she is the elegant member of a patrician family in the great maritime city of Genoa. Goya (Plate 17), to be sure, seems to tear off, often brutally, the splendour and pride of social position in order to reveal the human being naked in its feebleness and failings. But this is the spirit of satire or wit that feeds upon the discrepancy between pretended and actual existence. Rayski, on the other hand, is concerned with the human being, and like some of his great French contemporaries, Manet* above all, he has seized a psychological essence in a fleeting, irrevocable moment of this young life. The boy seems to have come into the room, seated himself down and immediately engaged in conversation with his friend who is about to paint his portrait.

The painting has seized much of a deep and exquisite relationship between the boy and the painter. Rayski was nearly fifty when he undertook this work at the request of the boy's parents. He was a friend of the family, often staying at the Einsiedel castle. He has also painted portraits of the count and the countess. But he was particularly drawn to the child whose premature death came as a blow to him, which he never seems to have quite overcome. In a painting of the Resurrection of Christ, for which he prepared several sketches, Haubold was to appear as an angel.

These biographical facts merely confirm the expression of the painting, which reveals a rare understanding of what boyhood really is, caught with the wistfulness of an older man's experience. We also seem to notice in this handsome little face something transparent, some shadow of that frail constitution that became apparent early in Haubold's short life. Clearly, this painting was more than just a commissioned portrait. In this respect, too, it resembles some of the French portraits of the nineteenth century. One of the finest portraits of this period, it is rendered poignant by a deep affection that still seems to vibrate through this masterfully simple and rapidly sketched composition.

Otto von Simson

19 In the Loge

Oil painting by Mary Cassatt, U.S.A. 1882

IN THE YEARS immediately after the Civil War, American painters had the greatest difficulty in surviving unless they were prepared to compromise. The situation was certainly difficult, but not altogether unproductive of result. The American tradition was still so weak that a continuation of a nationalistic school might have served only to increase provincialism. The influence of Germany and France contributed to the expansion of the American consciousness.

Mary Cassatt, for instance, was completely absorbed by the personality of the French painter and sculptor Edgar Degas*, choosing subjects and styles which were his. Yet she was never completely Parisian; she remained herself and that self was fundamentally American. She represented, in any case, an element in American society which, though a minority, was a vocal one; that segment of New York and Boston which believed that, for an American, Paris was not only a haven but a heaven. She responded to the actuality and grace of the city she made her own. She was often at her best in painting a mundane scene such as *In the Loge*. She revealed, too, her femininity in her emphasis on material feeling, yet she could never escape a certain lack of distinction; if her sense of paint was vivid, her handling of it was clumsy. As an artist she was as interesting as Whistler and perhaps more honest, but though determined to be chic she never had his taste.

Denys Sutton

Mary Cassatt was born in Pittsburgh, Pennsylvania, in 1845, of a family which had long standing European connections. She spent some years in Paris as a child, and in 1868 she decided to go back to Europe to study painting. After some time in Italy, she finally settled down in France, where she first exhibited her work at the Paris Salon of 1873. In 1877 she met Degas whose work, which she greatly admired, had a profound influence on her own. At his invitation, from 1879 onwards, she exhibited with the Impressionists and came to know the leading Impressionist painters of her time. Apart from occasional trips abroad and several visits to America, she spent the rest of her life in France and died at her château in Oise in 1926.

For a note on American Painting see *Man through his Art*, Vol. 5, *Love and Marriage*, Plate 20.

*See *Man through his Art*, Vol. 2, *Music*, Plate 17.

Bibliography

Denys Sutton
American Painting
Avalon Press & Central Institute of Art and Design, London, 1948

H. F. A. Sweet
Mary Cassatt
New York. 1967

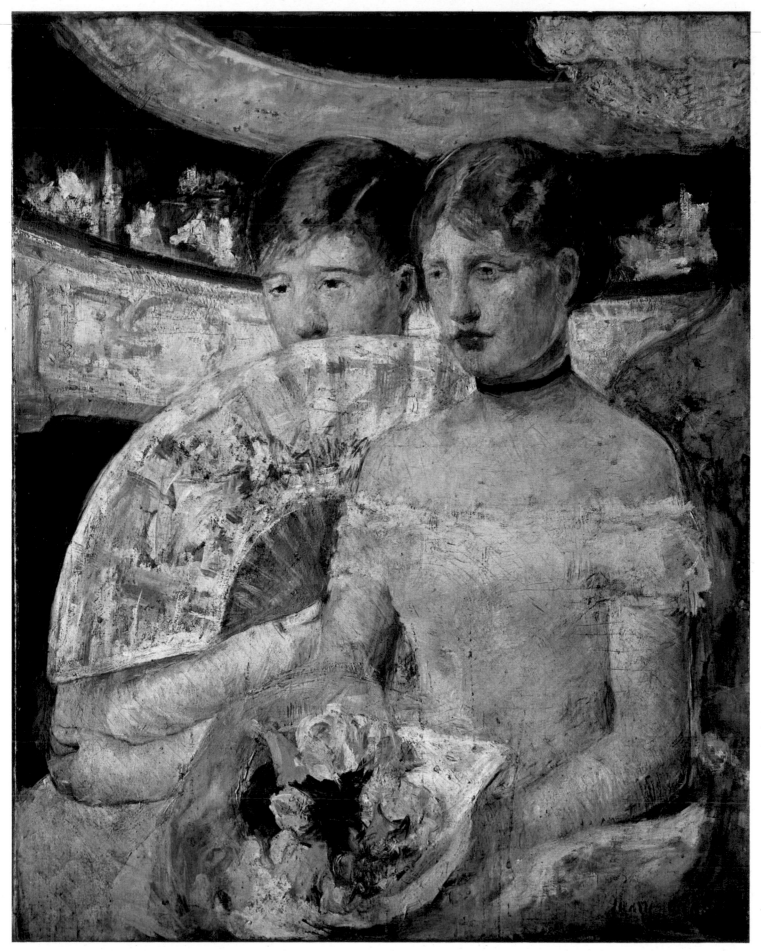

19. IN THE LOGE
National Gallery of Art, Washington

Mary Cassatt. 1882.
Oil painting. 31½ × 25⅛ in. : 79.9 × 63.9 cm.

Marcel Proust on his Deathbed 20A

Ink drawing by Dunoyer de Segonzac, France, 19 November, 1922

Plate 20A. Marcel Proust on his Deathbed. Ink drawing by André Dunoyer de Segonzac, France. 19th November 1922.

MARCEL PROUST considered the Dutch painter Vermeer's masterpiece *View of Delft*, 'the most beautiful painting in the world'. On visiting an exhibition of Dutch painting held in Paris (which included this picture), the great writer himself, only a few months before his death, suffered an attack of the grave illness that inspired this description of the death of Bergotte in his novel *A la Recherche du Temps Perdu*:

> The circumstances of his death were as follows. An attack of uraemia, by no means serious, had led to his being ordered to rest. But one of the critics having written somewhere that in Vermeer's *Street in Delft* (lent by the Gallery at the Hague for an exhibition of Dutch painting), a picture which he adored and imagined that he knew by heart, a little patch of yellow wall (which he could not remember) was so well painted that it was, if one looked at it by itself, like some priceless specimen of Chinese art, of a beauty that was sufficient by itself. Bergotte ate a few potatoes, left the house, and went to the exhibition. At the first few steps that he had to climb he was overcome by giddiness. He passed in front of several pictures and was struck by the stiffness and futility of so artificial a school, nothing of which equalled the fresh air and sunshine of a Venetian palazzo, or of an ordinary house by the sea.

61

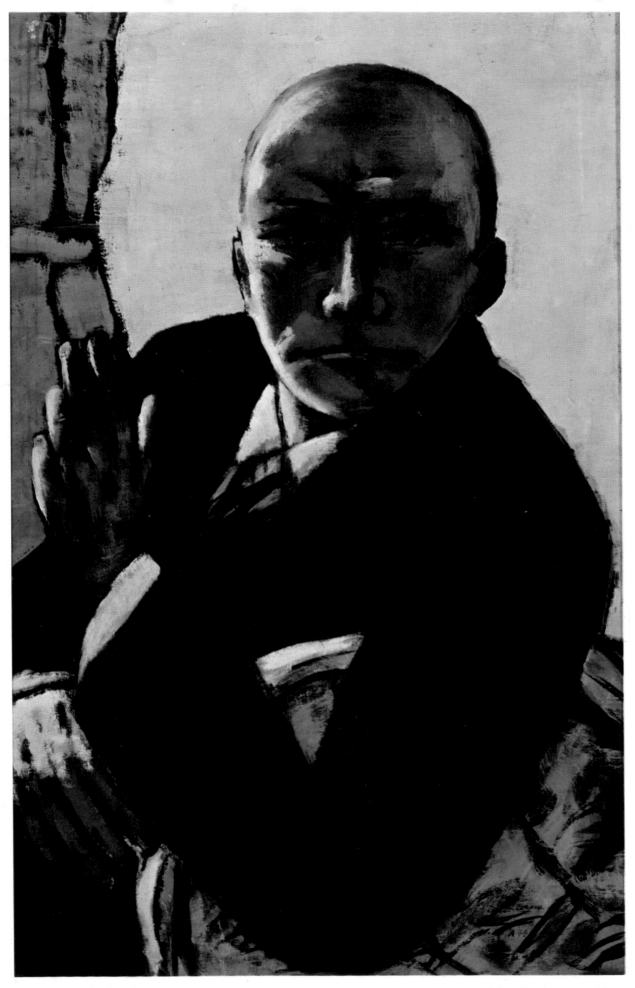

20. SELF-PORTRAIT
Bayerische, Staatsgemäldesammlungen, Munich

Max Beckman. 1944.
Oil painting. 37.4 × 23.6 in. : 95 × 60 cm.

Self-portrait 20

Oil painting by Max Beckmann, Germany

Fig. 20a. *Portrait of Vincent van Gogh. Ossip Zadkine. 1956.*

Max Beckmann (1884–1950) played an important part in the German Expressionist Movement of the first half of this century. After 1933, political persecution under the Nazi régime forced him to leave Germany for Holland and later the United States. His work, frequently portraying war and man's brutality, is essentially concerned with the problems of our existence and after obtains such force that it has an almost physical effect on the spectator.

This century is not necessarily that within whose confines the period referred to as *Expressionist* falls. In Germany, this refers, roughly speaking, to the years 1900 to 1930, but if this part of our century is labelled *Expressionist*, perhaps because a literary, pictorial, musical and theatrical Expressionism quickened and inspired all the great German aesthetic movements, one must, nevertheless, realise that Expressionism, a specifically German phenomenon, is not solely German. To take painting alone, there was, at the same time, a French Expressionism (Rouault), a Russian (Soutine), a Spanish (Solana), a Flemish (Permeke), and, moreover, the 'fathers' of Expressionism are rightly believed to be Ensor, Van Gogh, and Edward Munch. Expressionism, in fact, far from being a simple event, seems

Fig. 20b. *Detail from self-portrait. Vincent van Gogh (1853–1890). Holland.*

THIS SELF-PORTRAIT by the German Expressionist painter Max Beckmann is the work of an artist whose main subject was the human figure, in which he said he tried to express man as 'a monster of such terrifying, convulsive vitality'. It is a character in a play by George Kaiser who has best defined Expressionist man when he said: 'We live from explosion to explosion.' It is, in fact, an explosion of the passions and feelings which records, like a seismograph, the artist's self-portrait, impatient as the latter is to seize and fix, not his existence in its duration and continuity, but, on the contrary, the extreme point of a state of crisis – a psychological crisis, but more than that, the reflection and consequence of a social crisis. When Rembrandt (Plate 16) examines himself in front of his mirror, he is alone, and the coincidence of self and image is so strong that there is no room between them for the intrusion of a foreign element. Rembrandt's solitude is material and metaphysical. Expressionist man, himself, is also alone, but about him is the restless, turbulent noise of the crowd. This noise is so insistent, so demanding, that it ultimately encroaches upon solitude. Expressionist man's solitude is qualitatively greater than the clamour of the crowd about him, but unknowingly and in spite of himself he belongs to this crowd, and his personality, even the part of himself which is most singular, most extraordinary, remains conditioned by the human block of which he is a part. The anguish apparent in the Expressionist self-portrait is not the result of a complete falling-back upon oneself, which leads to a suppression of spatial and temporal categories in favour of that absolute freedom from time and space; it is no longer the anguish born of doubts which man conceives in the meditations upon himself and his destiny, in the form of God, in which he involves himself. Expressionist man does not aspire to escape from his epoch: he desires, rather, to embody that epoch, to condense it in himself, since into him flow and converge all the great streams of events and ideas that define a century.

It is no longer enough for the individual to resolve his own psychological and metaphysical problems, he must also take upon himself the problems of the universe in which he lives, and of which he is a part. Rembrandt was turning his back upon society when he employed self-portraits to enable himself to examine his conscience and that part of his destiny which was a matter between himself and God. Expressionist man confronts society in order either to communicate with it, or to contend with it. In the latter event, the position of confrontation of adversaries, expressed by grappling with one another, physically unites the antagonists who are spiritually divided. The combat links the opponents; this is why Expressionist man, even in his most introverted self-portrait, seems to be drawn outside himself, to be thrust towards an outside, a beyond, empty of philosophical meaning, but of immense social significance.

The Expressionist portrait is not a compound of moments seen separately and reassembled afterwards in an image which represents the unity and the constant of a personality; it does no more than fix the appearance that the trigger of a camera would be able to secure. It matters little if this snap-shot arrests only the accessory, the artificial, the temporary, since the man of that moment is only an exception in this combination of diverse individualities of which the personality is formed: it is the explosive violence of gesture, of look,

which alone counts because it indicates a passion or an emotion approaching its culmination, roused to bursting-point. Living from explosion to explosion, and probably for the sake of explosion, Expressionist man avoids continuity; for him there exists no link between the present moment, at its briefest and most 'explosive', and the moment which precedes it or the moment which follows it. The violence of the crisis which he sees, during that moment fixed by the portrait, annuls all that belongs to the past, since that which was is irretrievably destroyed and is as if it had never been. As for the future, one may believe that the extreme point of the emotions and passions to which Expressionist man attains does not involve any future of which he should take account; the explosion signifies negation of all continuity. While supposing, even, that it does not suppress all duration, it only allows time an interrupted march.

Living in an unstable and threatened world, Expressionist man is torn between contradictory feelings: he loves that risk, that danger, which, at every moment, places his life in physical or spiritual peril: rejecting continuity, he gives the moment its maximum intensity and significance; but the tension and saturation of this desire to be ful-filled immediately and in every moment, such as the look indicates, whose brutality does not exclude melancholy, give birth to an anxiety which may be the despair caused by the conviction that one can keep nothing which one has once possessed, and provoke the Faustian cry: 'Stay, thou art so beautiful'. Set against this exaltation, which the sensation of 'living dangerously' attains, in a completely changed world, itself threatened with destruction, the nostalgia for that which was and which will not return, the consciousness that there is only existence in continuity, and that evolution is but a Heraclitean stream whose waters neither re-flow nor cease to flow, add to the expression of heroic defiance which is in his look, the dialogue of restlessness and pure action rejecting thought, doubt, reflection.

This existence of instinct which the Expressionist self-portrait reveals, whether it be of the nineteenth or twentieth century, by Munch or Van Gogh, Corinth or Ensor, which is devoted to the tragic and tells of a visit to metaphysical hells, is seen in perpetual conflict, between the artist's self and the outside world, and between the numerous selves which fight for control of his inner world. He is incapable of contemplation because this requires an established posi-tion in time, a limit to, and organization of, the successive explosions which make up the life of an individual *actus tragicus*, in which man is both the place and the actor. All he could do, previously, to reassure himself and encourage himself to build towards the future and for the future, has been withdrawn, and acknowledged to be useless. The wealth of this Expressionist man consists, therefore, of money which no longer has credit, and he is no longer satisfied with the social, moral and spiritual structures upon which the immutable can still lean.

Living thus, with illusions which he believes to be realities, and realities in which he has no confidence, since he takes them for illusions, he only gives to his own existence a reality which is equally uncertain. Action alone can convince him that he exists; he also seeks it in the gratuitous and even in the absurd. The Faustian appearance of the Expressionist portrait, whichever century it belongs to, reveals the confusion of the thoughtful man who has chosen action without being able to find sufficient grounds for it, and senses that by doing so, he has lost the only chance he would have to believe in his own existence and that of the world around him.

Marcel Brion

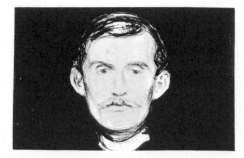

Fig. 20c. *Detail from self-portrait. Edward Munch, Norway. 1895.*

Fig. 20d. *Detail from self-portrait with Monocle. Karl Schmidt-Rottluff, Germany. 1910.*

to be a constant chiefly German in character and career.

The development of art in Germany and the German states towards the frontiers of Renaissance and Baroque, coincides with the great crises of religious conscience and social up-heavals, the one marked by the advent of the Reformation, the other by the Peasants Revolt; the same situation of revolt stirred the first third of the twentieth century. If one compares the self-portraits of Dürer, Munch, Beckmann and Van Gogh, one recog-nizes in their expressions the same instability of existence, -continually disturbed by the blankness of the future, the same uncertainty in the face of problems of conscience or society, the same anguish caused by the com-munication of the present with the future.

M.B.

Bibliography

(Ed: Andrew Carnduff Ritchie)
German Art of the Twentieth Century
Museum of Modern Art, New York, 1957

(Introd. John Willett)
Catalogue: Max Beckmann, 1884–1950
The Arts Council, London, 1965